LONDON STREET PHOTOGRAPHY 1860-2010

First published in the UK in 2011 by
Dewi Lewis Publishing
8 Broomfield Road
Heaton Moor
Stockport SK4 4ND
England

www.dewilewispublishing.com

For the texts: Mike Seaborne, Professor Jack Lohman, Anna Sparham
For the photographs: see photo credits
For this edition: Dewi Lewis Publishing / Museum of London

ISBN: 978-1-907893-09-4 (softback)
ISBN: 978-1-907893-03-2 (hardback)

Design and artwork production: Dewi Lewis Publishing
Print: EBS, Verona, Italy

Reprinted July 2012

LONDON STREET PHOTOGRAPHY
1860-2010

Selected from the Museum of London Collection
by Mike Seaborne & Anna Sparham

in association with
dewi lewis publishing

FOREWORD

I am delighted to introduce this book about London's street photography. Originally published to accompany an exhibition at the Museum of London, it is based on the Museum's collection of historic photographs, a collection that has been built up since 1979 when the Museum appointed its first curator of photographs. Before 1979 photographs had found their way into the Museum's collections, but very much as secondary material; as documentary records of London sites or events, for example. As with many museums, it took a while to appreciate the historical and visual significance of photographs as objects in their own right.

Today, the photographic collection is well-known and much-valued as a rich and rewarding source for understanding London, past and present. The distinctive qualities of photographs have come to the fore and we have started to look with new interest at images that would once have been dismissed as not sufficiently interesting. This is particularly so for images that fall into the category of street photography. What these 'snapshots' lack in formal qualities, they make up for in sheer expressive force. These are images that can literally stop time; they catch a fleeting moment, freeze a gesture, snap an ephemeral sight before life and the city moves on. These are images that speak of spontaneity and movement, rather than formal composition; they capture the dynamic flux of the city and by doing so allow us to gaze on it at our leisure.

It is this ability to convey the ebb and flow of city life that makes street photography so well suited to London. For centuries, the look of the city has been one of massive and incomprehensible human variety. *'The great interest of London is the sense the place gives us of multitudinous life'* said the novelist Henry James in an 1893 essay on London, going on to add that what London-lovers relished was *'the rumble of the tremendous human mill'*. This London rumble echoes through all the images here, from the very earliest portraits of 19th-century street characters, to the surreal images of street life taken by today's generation of street photographers.

Looking at these images is an enjoyable and rewarding way of reflecting on London itself. Although it is always wise to recall the words of one of London's most famous photographers, Bill Brandt, in 1948: *'London is something too complex to be caught within a set of views or by any one photographer.'*

Professor Jack Lohman
former Director, Museum of London

Street photographers are one of many flavours of modern historians.[1]

INTRODUCTION

Street photography thrives in London today. It documents the movement, diversity and seeming incoherence of the most multicultural city in the world. However, photographing life on London's streets is nothing new. The first 'instantaneous' London street scenes were taken in the early 1860s, and by the 1890s candid street photographers were snapping Londoners unawares. The 20th century saw many photographers, famous and lesser-known, capture life on London's streets for a variety of reasons.

Street photography is often regarded as a style of urban documentary photography that captures candid images of people. Definitions vary widely, from *'any photograph made anywhere in public places'* [2] to *'un-posed scenes that trigger an immediate emotional response, especially humour or fascination with ambiguous or surreal happenings'* [3]. Some emphasise the 'decisive moment' aspect of street photography, whilst others eschew defining what a street photograph should look like.

In their introduction to *Bystander: A History of Street Photography*, Colin Westerbeck and Joel Meyerowitz note that at its core, street photography is about making candid and spontaneous pictures of everyday life in the street. They believe that *'The combination of the camera, as the instrument, and the street, as subject matter, yields a type of picture that is idiosyncratic to photography'* [4].

Nick Turpin, founder of the *In-Public* group of street photographers, goes further, believing that *'Street Photography is just Photography in its simplest form – it is the medium itself'* [5]. He is a champion of the spontaneous approach over the pre-meditated, conceptual or constructed work that characterises much contemporary art photography.

Another commentator, Phillip Greenspun, observes that *'The best thing about street photography is that it is possible for the viewer to see more than the original photographer'* [6]. Certainly, looking at old photographs, what can sometimes seem most interesting to us is not the photographer's intended subject but something else he or she, perhaps unwittingly, included in the frame. It is these incidental details – things over which the photographer may have had no control – that lend street photographs their strong flavour of authenticity.

Inevitably, the 'look' of street photographs is something that has evolved with the development of the medium itself. In the very early years exposure times were too long to capture movement, but, in the 1860s, Valentine Blanchard's experiments in London with a small-format stereoscopic camera led to the first photographs of busy city streets in which everything in motion – traffic and people – was arrested in sharp definition. One reviewer marvelled that, *'As pictures, they are brilliant and harmonious, and as accurate portrayals and valuable souvenirs of the daily street life of the busiest metropolis of the world, we have seen nothing at all to equal them'* [7].

Small stereoscopic photographs were of rather limited use, however, and some photographers attempted to record street

life using the conventional large-format cameras of the day. They either had to ask people to break off from what they were doing whilst the exposure was made or wait until a curious self-posed crowd had gathered in front of the camera. The resulting pictures are far removed from the grab shots we associate with today's street photography, but they do represent largely successful attempts to document something of what was going on in the street. A fine example of this was John Thomson's 1877 series, *Street Life in London*, which is one of the world's first published series of social documentary photographs.

Around 1890 several technical developments in photography came together to produce the first multi-shot, hand-held cameras with exposure times short enough to capture moving objects. The street camera was born, and with London at its imperial zenith, it was the perfect tool for capturing the vitality and movement of life in the world's largest metropolis.

The pioneer of candid street photography in London was the amateur Paul Martin who, in the early 1890s, began using a camera disguised as a parcel to photograph people unawares. His photographs were derided at the time for being 'inartistic' but he persevered and, writing retrospectively in 1939, noted that *'Singularly little photographic evidence is available to illustrate how the man in the street behaved even fifty years ago, partly because cameras were not quick enough in action, and still more because photographers did not think of wasting precious plates on scenes which seemed to have no particular interest.'* [8]

Paul Martin went on to become one of the first London press photographers. For years newspapers and magazines, such as the *Illustrated London News*, had been copying photographs to make woodcut engravings for reproduction, but in the early 1900s it became possible to reproduce photographs directly. Press photography quickly grew as a profession, further promoting the development of fast-acting, hand-held cameras that, together with new amateur roll film cameras, such as the Kodak, enabled an ever-growing number of photographers to take to the streets.

Press photographers flocked to newsworthy events in search of an arresting image and some went further, catching people off-guard or in unexpected places. They mostly worked anonymously for news agencies but a notable exception was Horace Nicholls who had established a reputation as a war correspondent in South Africa during the Boer War. On returning to London in about 1900, Nicholls set up business as an independent photographer selling prints to publishers and the press. His candid photographs of well-to-do Edwardians at leisure during the London Season are particularly revealing.

By 1930 photographic technology had matured enough to allow photographs to be taken almost anywhere. New precision 'miniature' cameras, notably the 35mm Leica and 6x6cm Rolleiflex, together with film sensitive enough to take 'available light' photographs in most conditions, greatly extended photography's horizons. At the same time,

photographs of 'life as it is' became the stock-in-trade of a new generation of popular magazines, notably *Weekly Illustrated* (1934) and *Picture Post* (1938), both published in London.

These magazines, which soon achieved mass media status, aimed to hold a critical mirror up to British society. Using an extended picture-story format, they documented London's deep social contrasts alongside its ever-changing street life. Such social observation was part of the contemporary *zeitgeist*. Many photographers, along with documentary film-makers, writers and painters, saw themselves as working within a political framework, providing visual evidence of inequality and social ills.

Reportage and documentary photography flourished in Britain in the 1930s, due in no small part to an influx of émigrés from Central and Eastern Europe. Fleeing fascist regimes, these new arrivals, who included Bill Brandt, Cyril Arapoff and Wolf Suschitzky, brought a fresh approach to photography honed on European Modernism and helped change the way images were framed. Many also played a key role in the cross-fertilisation of still photography and the documentary film movement.

Photography during the Second World War was inevitably proscribed by censorship. Images taken by accredited photographers working for newspapers and press agencies were officially vetted and street photographs were usually only passed if they could be used for propaganda purposes.

Nevertheless, a few of these images, such as those by Bert Hardy and George Rodger, qualify as very fine street photographs.

The great social and cultural changes that took place after the Second World War provided a new impetus for street photography. Traditional ways of life changed forever as post-war reconstruction and American cultural influences reshaped landscapes and aspirations. A desire to capture the 'old' before it disappeared saw many photographers flocking to London's working-class areas, much in the manner of their 1930s predecessors. Yet the photographs taken by this new generation were informed as much by Beat culture and American Abstract Expressionism as any sense of British tradition.

The best-known London street photographer of the 1950s was Roger Mayne. He photographed consistently in a rundown area of North Kensington that had been damaged during the War and was due to be replaced by a new comprehensive housing scheme. Realising that not just the Victorian terraced houses but a whole way of life was under threat, Mayne became a familiar, and accepted, figure as he hung around the streets, folding Zeiss Ikonta camera at the ready.

In the 1960s and 1970s, many London photographers saw themselves as part of wider social and cultural struggles. A Community Photography movement developed with the twin aims of making photography more accessible to

working-class people and documenting, often critically, the structural shifts taking place in society. De-industrialisation, in particular, threatened to break up established communities and so locally-based photographers such as Paul Trevor made it their business to immerse themselves in areas like London's East End to document everyday life before newcomers displaced the predominantly working-class population. Trevor moved to Brick Lane in Shoreditch in the early 1970s and photographed life on the street almost every day for the next ten years.

However, further cultural shifts in the 1980s and 1990s saw the traditional documentary aesthetic in decline. The widespread adoption of colour and the embrace of the art market shifted interest to more conceptual work. At the same time, post-modernist critiques questioned the documentary validity of the medium itself and the mass media, driven by the cult of celebrity and the need to maximise advertising revenue, increasingly turned their attention away from the harsh reality of everyday life.

Partly as a reaction to this, the last ten years has seen something of a revival of interest in independent street photography. Digital technology has opened up new ways of making images, and the World Wide Web of sharing them. *In-Public*, founded in 2000 as the first ever international collective of street photographers, is doing much to promote the genre through exhibitions and publications, and this

despite recent anti-terror laws and a new suspicion of people taking photographs in public places. This renaissance is particularly vigorous in London, where street photographers are finding the city a place of intense visual stimulation, bursting with picture-taking possibilities.

Today's street photographers are also aware that their work may well form part of the historical archive of contemporary images for future generations to consider. They believe that street photography is crucial to a more accessible and accurate public record of what life was really like in the early 21st century.

Mike Seaborne

1. www.deviantart.com 6/10/10
2. www.nonphotography.com/streetphotography 6/10/10
3. Nick Turpin, www.sevensevennine.com 6/10/10
4. *Bystander: A History of Street Photography* by Colin Westerbeck and Joel Meyerowitz, Thames and Hudson, 1994, p34
5. Nick Turpin, www.sevensevennine.com 6/10/10
6. Phillip Greenspun, www.photo.net/learn/street/intro 6/10/10
7. Bill Jay, www.billjayonphotography.com/writings 6/10/10
8. *Victorian Snapshots* by Paul Martin, Country Life, 1939, p44

1860-1889

George Washington Wilson
Henry Dixon
Valentine Blanchard
John Thomson
Arthur Eason

George Washington Wilson Royal Exchange, c.1875

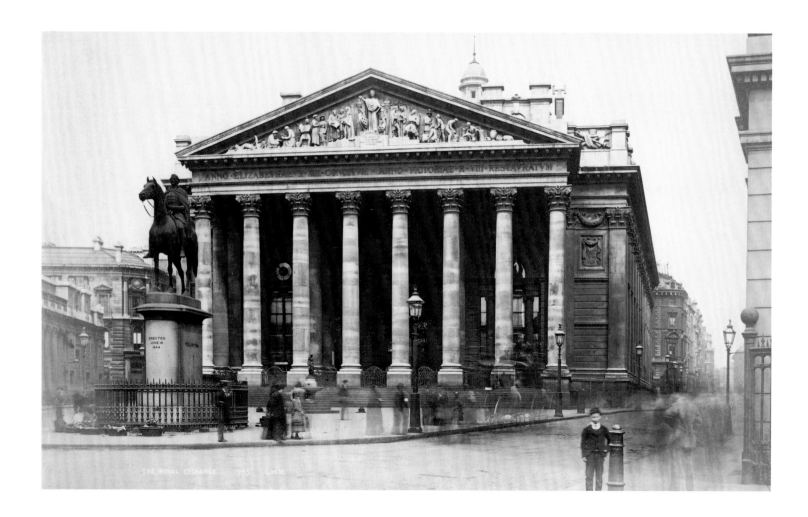

Henry Dixon
Old houses, Aldgate, c.1882

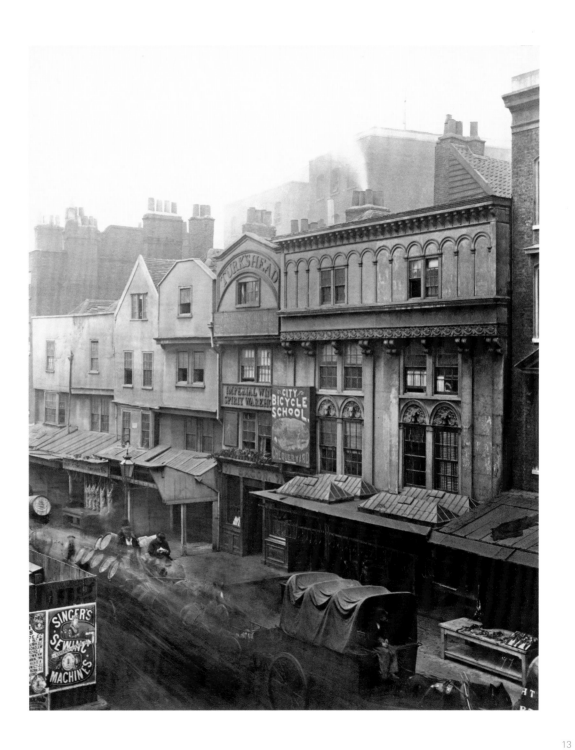

Valentine Blanchard Temple Bar, Fleet Street, c.1862

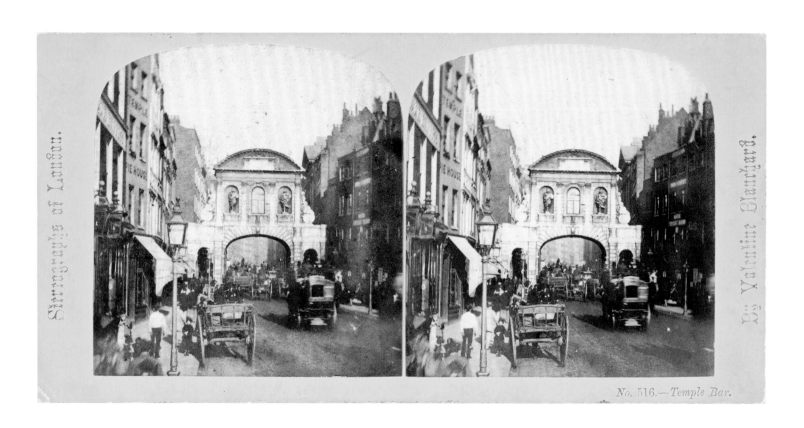

Valentine Blanchard
Covent Garden Market, c.1860

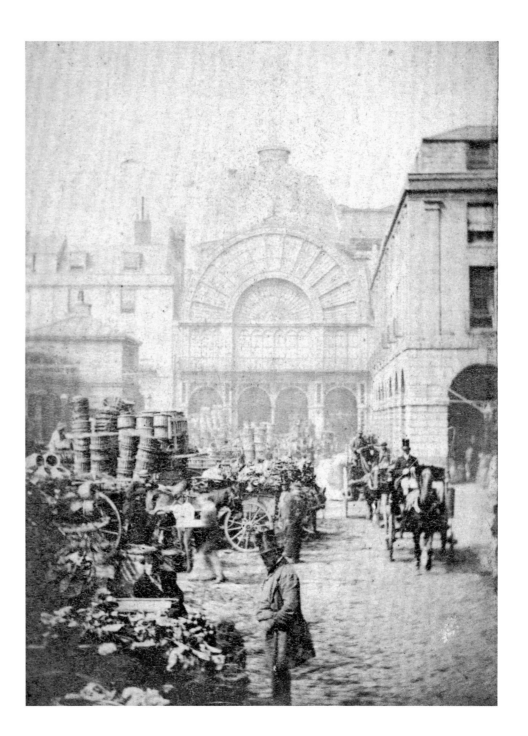

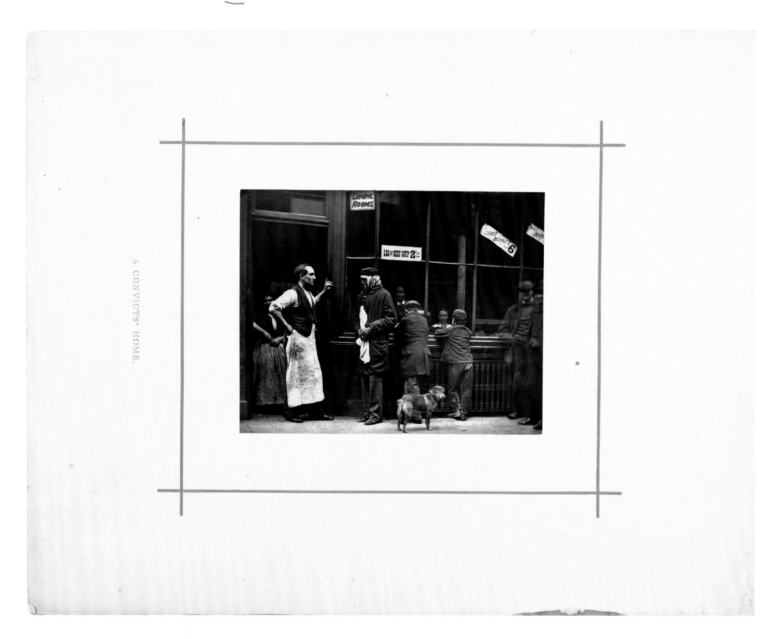

John Thomson
"Hookey Alf" of Whitechapel,
c.1877

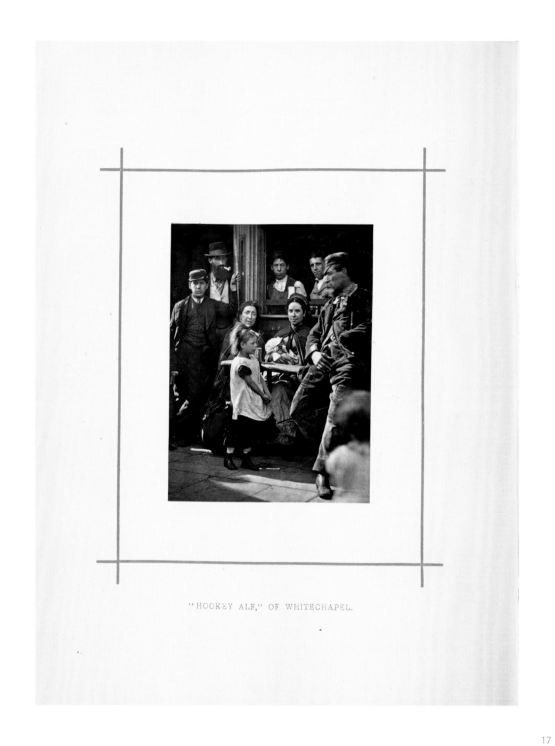

"HOOKEY ALF," OF WHITECHAPEL.

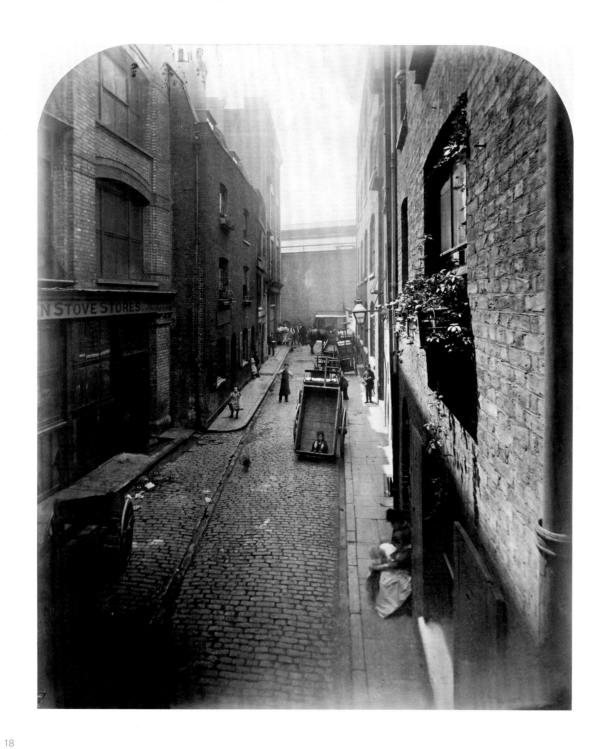

1890-1929

Paul Martin
Charles Wilson
Anonymous
John Galt
Christina Broom
Horace Nicholls

Paul Martin A porter at Billingsgate Market, 1893

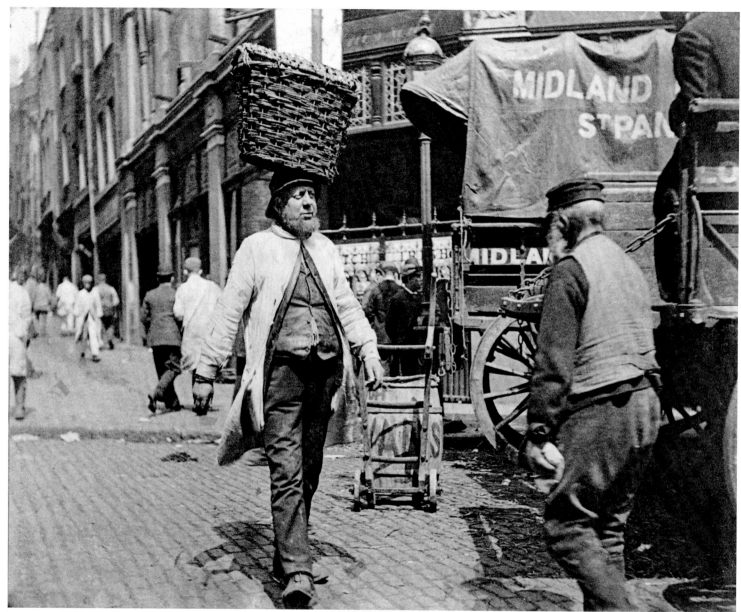

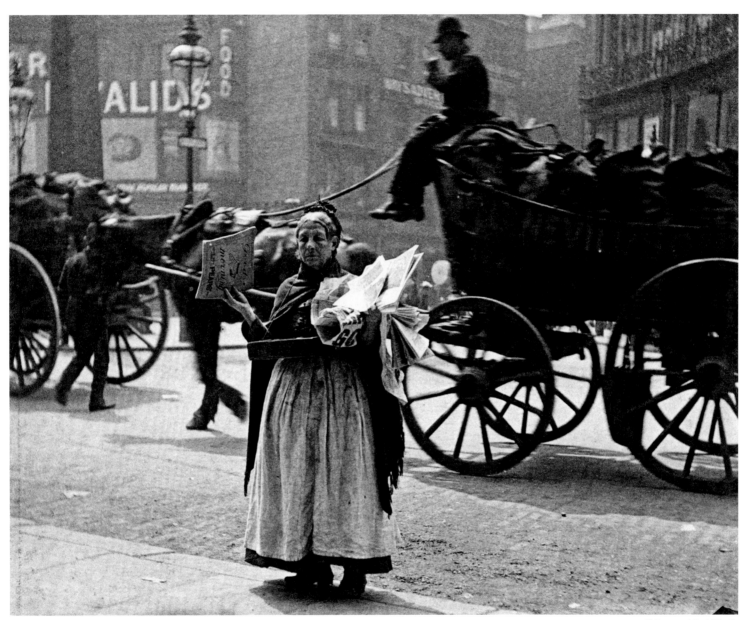

Paul Martin A blind man at Caledonian Cattle Market, c.1895

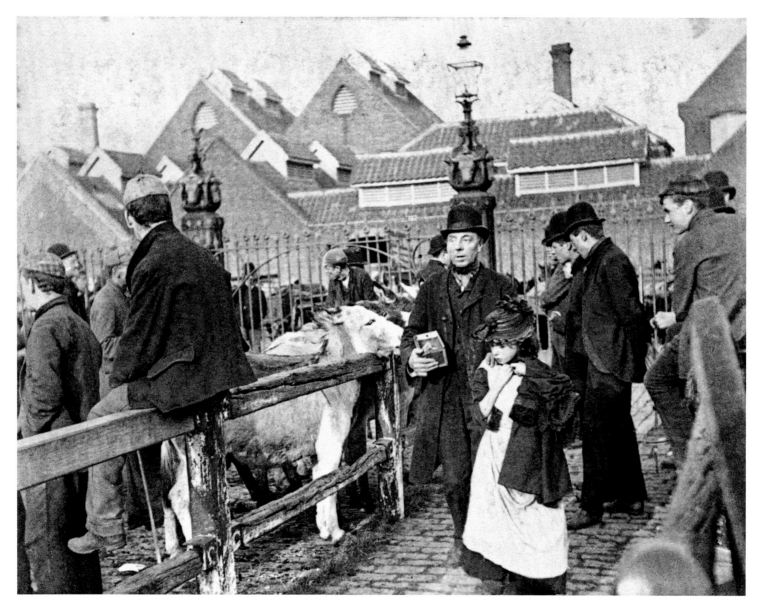

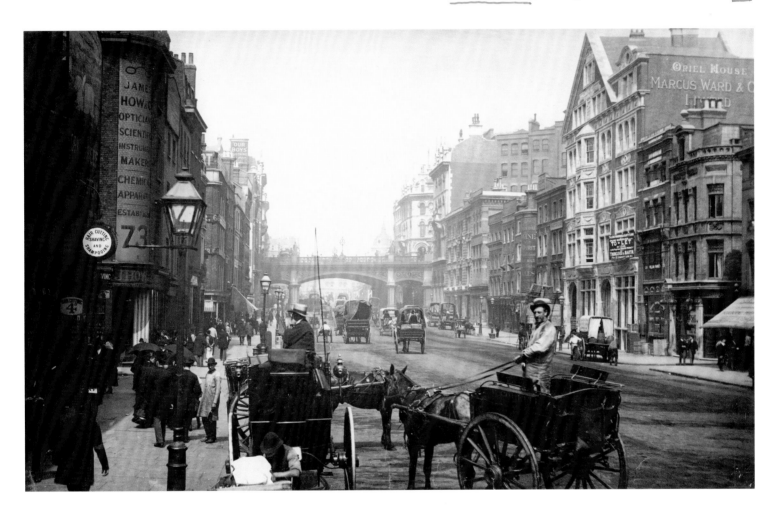

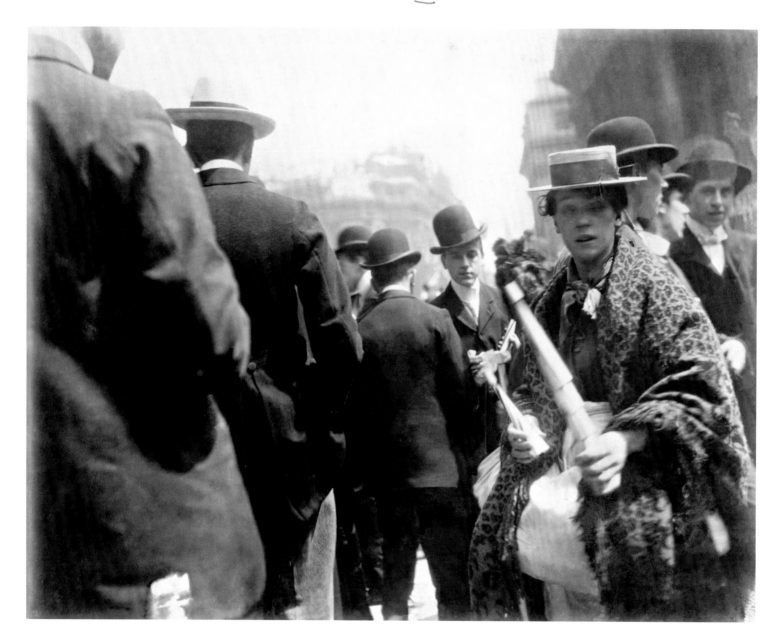

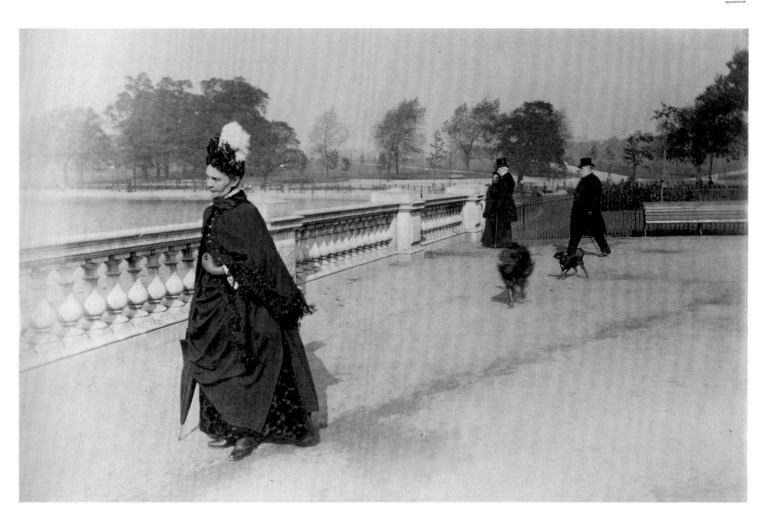

Anonymous Cornhill, c.1900

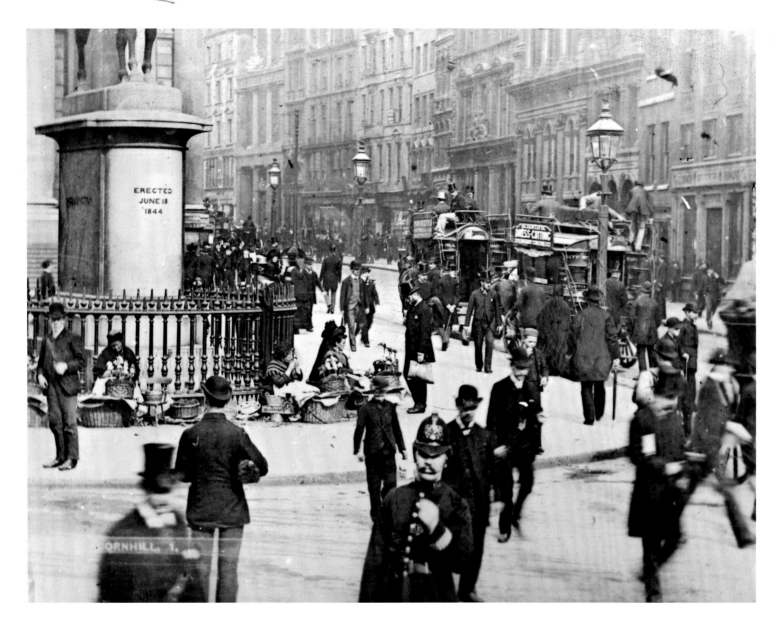

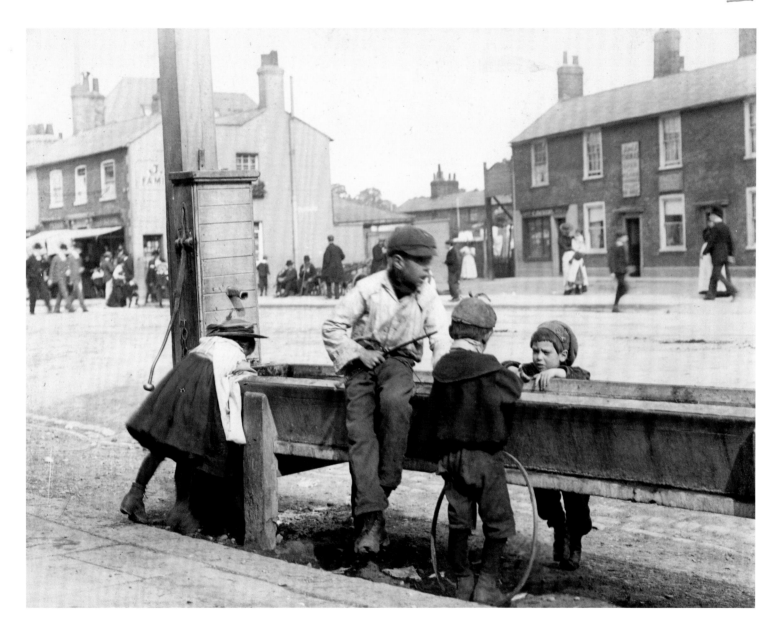

Anonymous Bank, c.1900

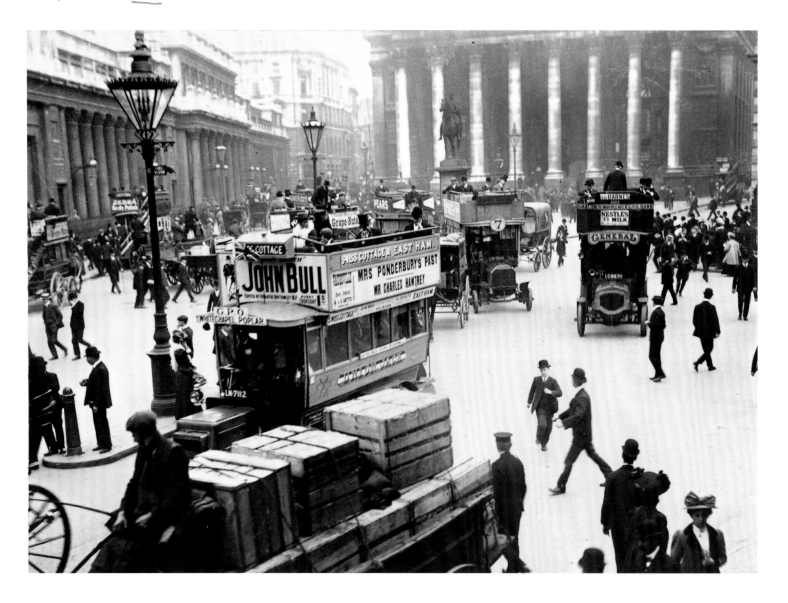

Anonymous
London Bridge,
South Side, c.1900

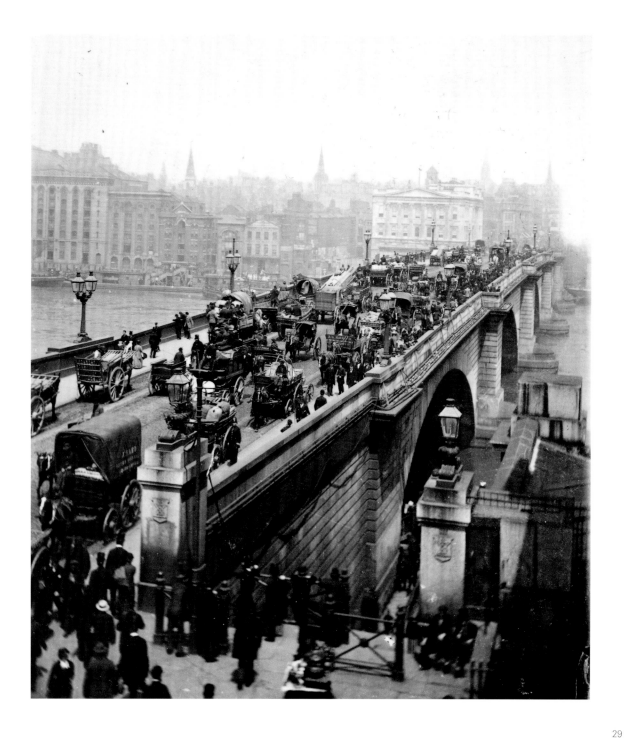

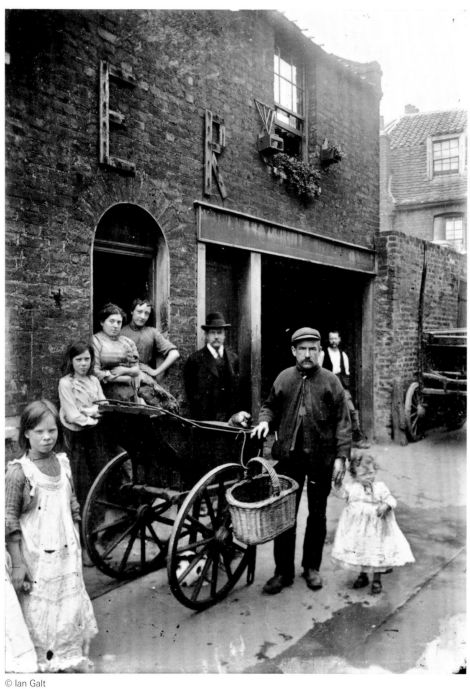

John Galt
Cats' meat man in an
East End Street, c.1902

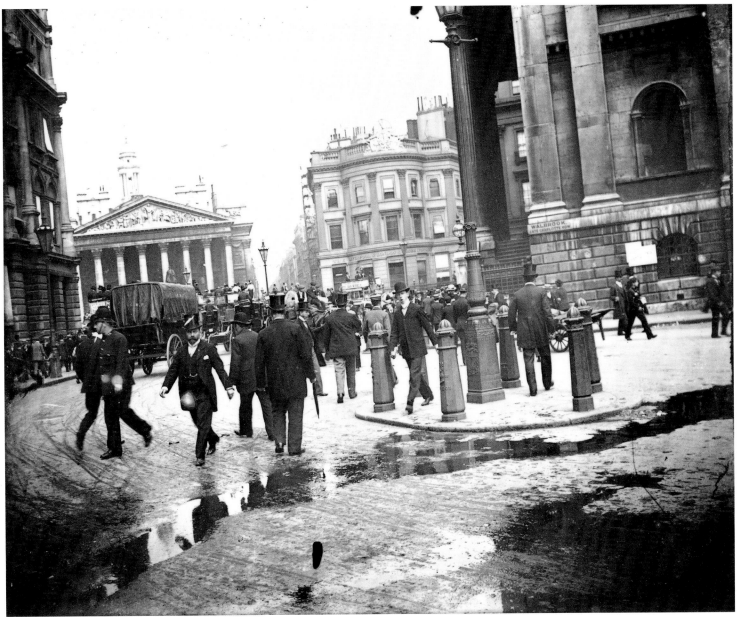

Christina Broom Sloane Square, SW., c.1905

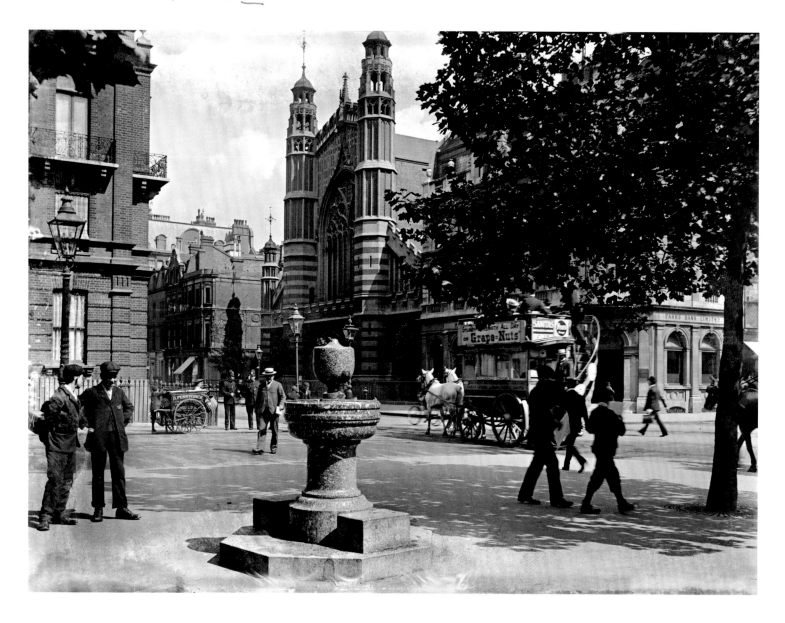

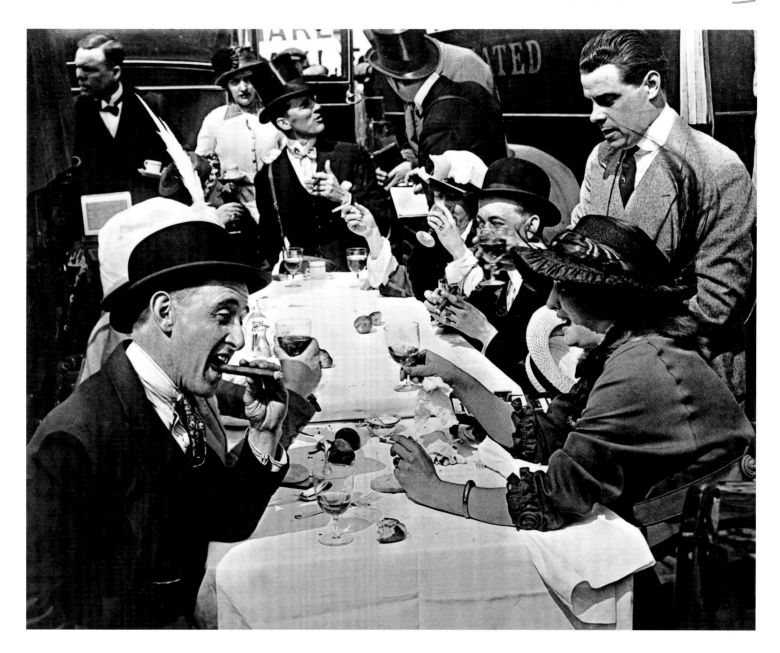

Anonymous A street seller of toys, c.1920

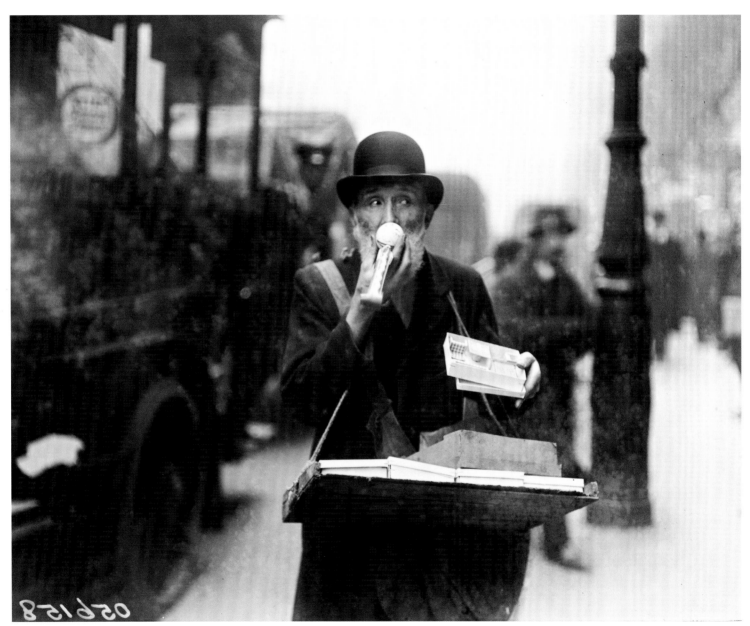

1930-1945

George Reid

Anonymous

Hans Casparius

Felix Man

Cyril Arapoff

László Moholy Nagy

Margaret Monck

Humphrey Spender

Wolf Suschitzky

Bert Hardy

George Rodger

Bror Bernild

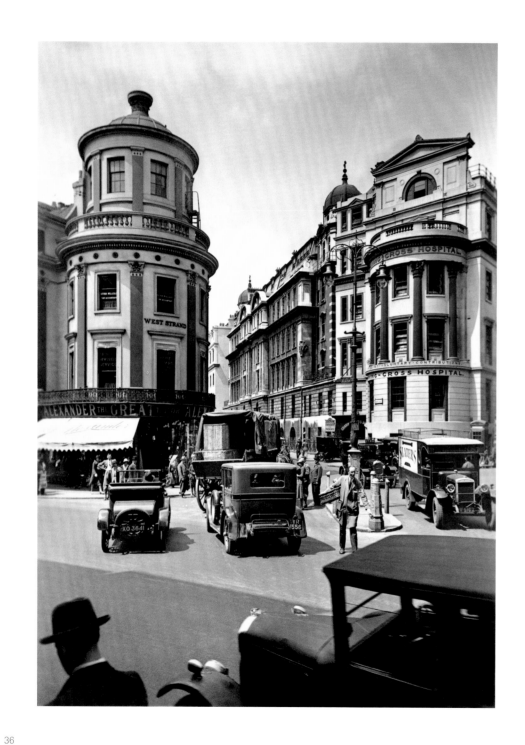

George Reid
King William IV Street and
Charing Cross Hospital
from The Strand, c.1930

George Reid
Fleet Street, looking west, c.1930

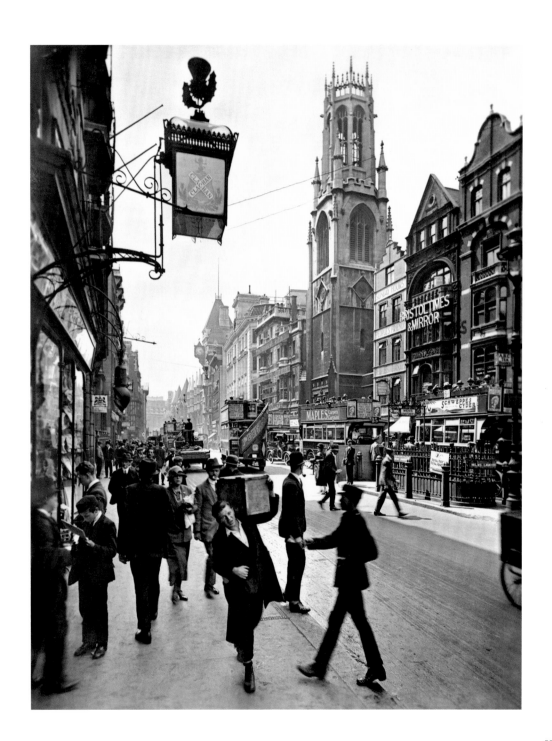

Anonymous
Passers-by walking along
Sutton High Street, c.1930

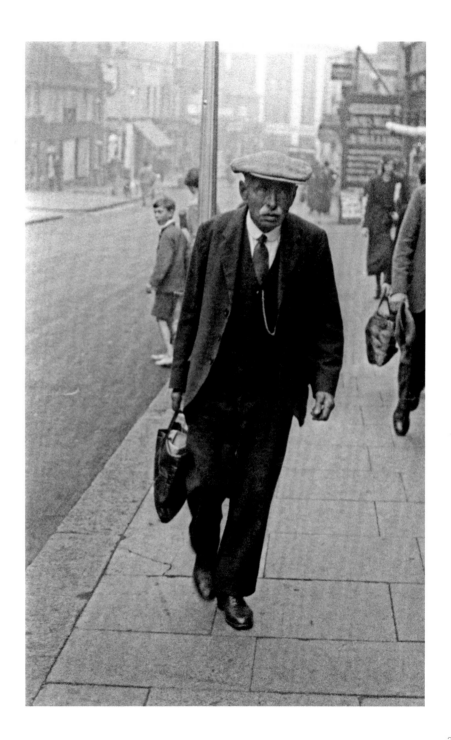

Hans Casparius Avery Row, W1,1930

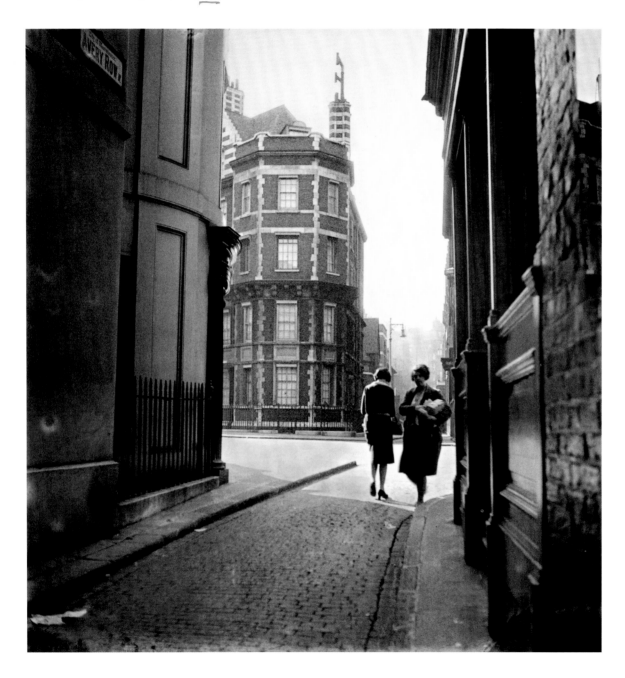

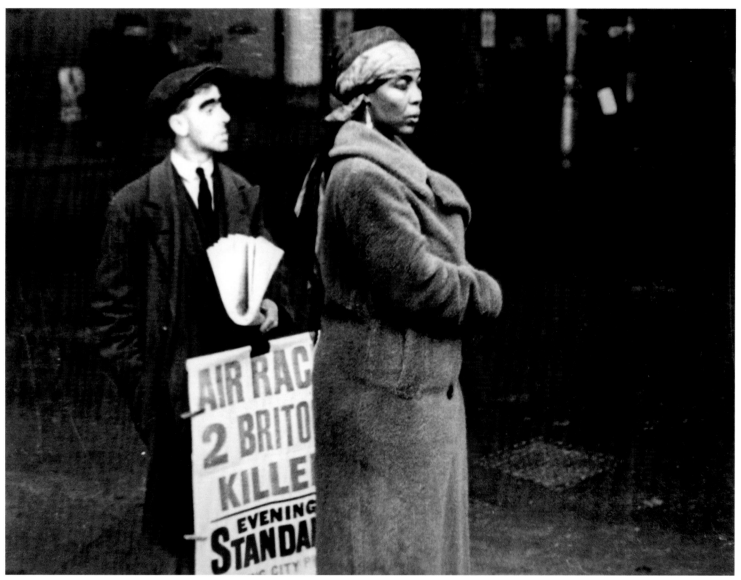

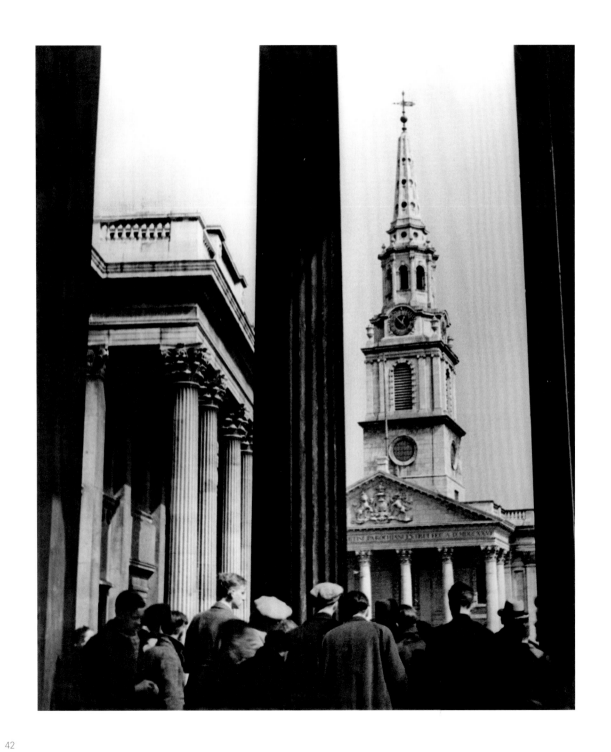

Cyril Arapoff
St. Martin-in-the-Fields
Church from the
National Gallery, c.1935

Cyril Arapoff
Children in a street
in Poplar, c.1935

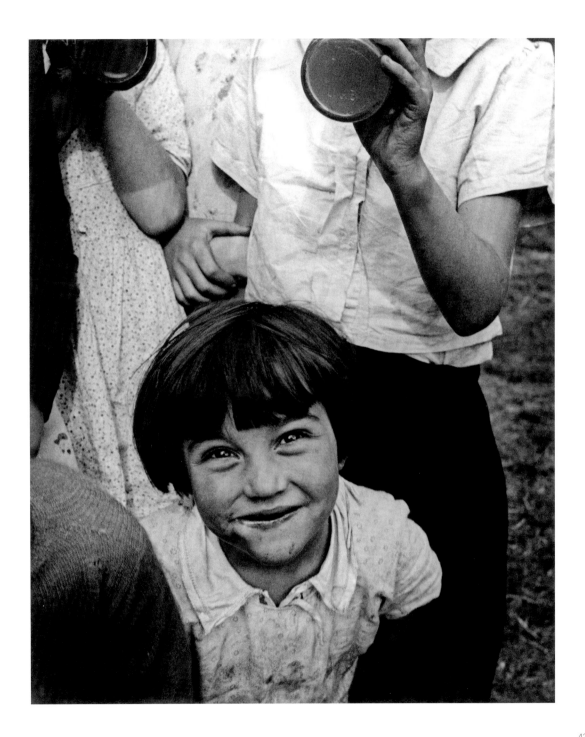

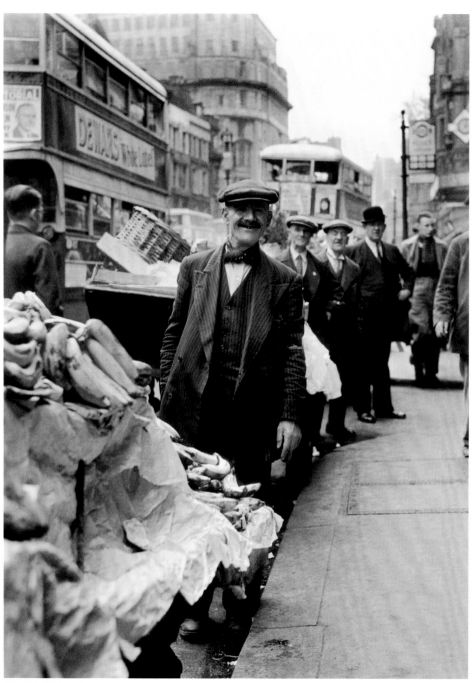

László Moholy Nagy
Street seller with his barrow,
Central London, 1936

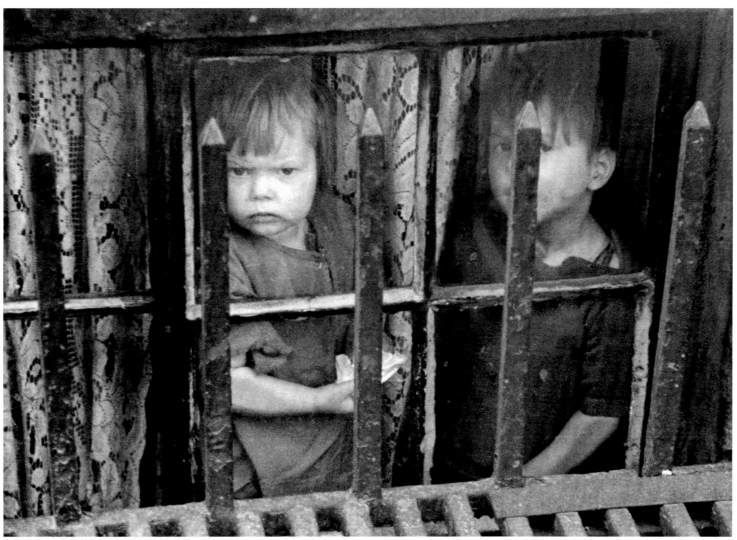

Margaret Monck A nun walking through Kensington Gardens, c.1935

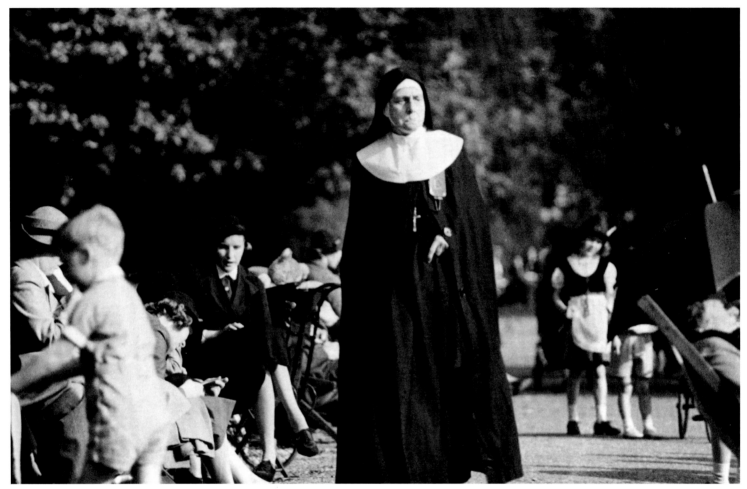

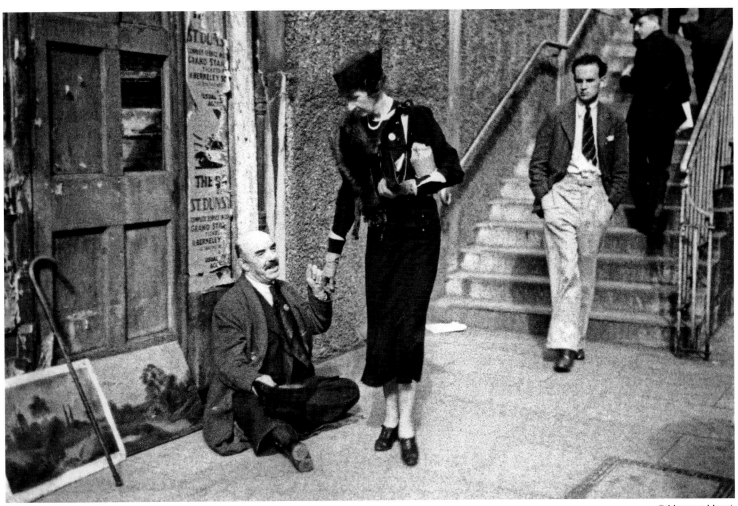

Humphrey Spender A nanny and her charge at The Round Pond, Kensington Gardens, c.1935

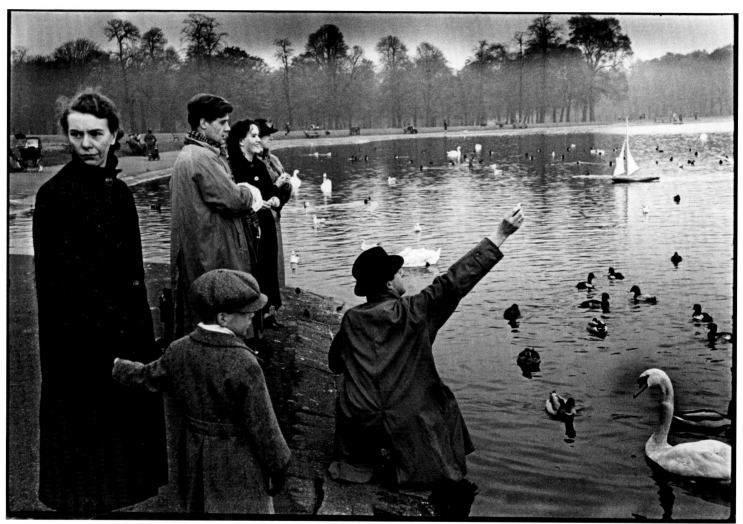

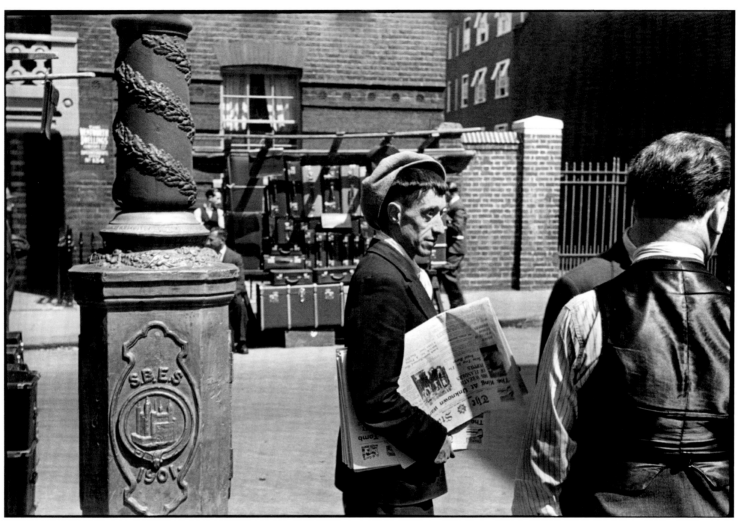

Wolf Suschitzky A milkman, Charing Cross Road, 1937

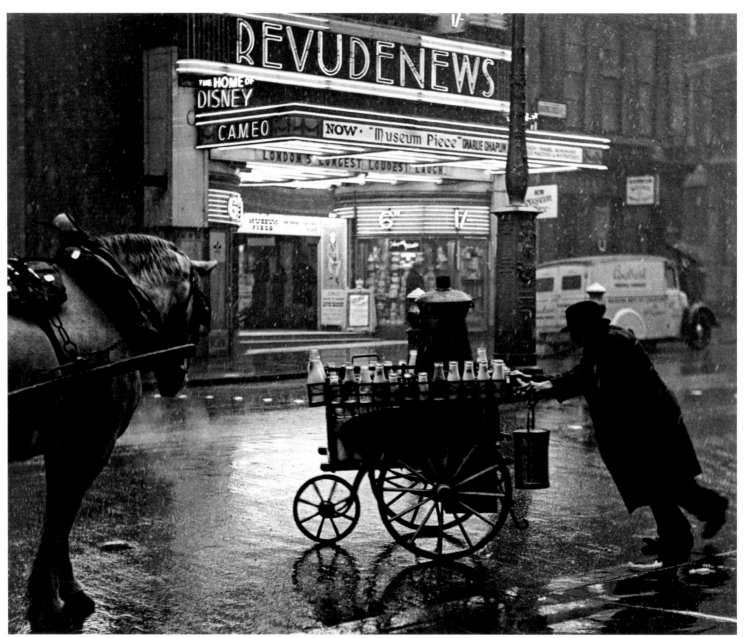

Wolf Suschitzky
Cambridge Circus,
Charing Cross Road, 1937

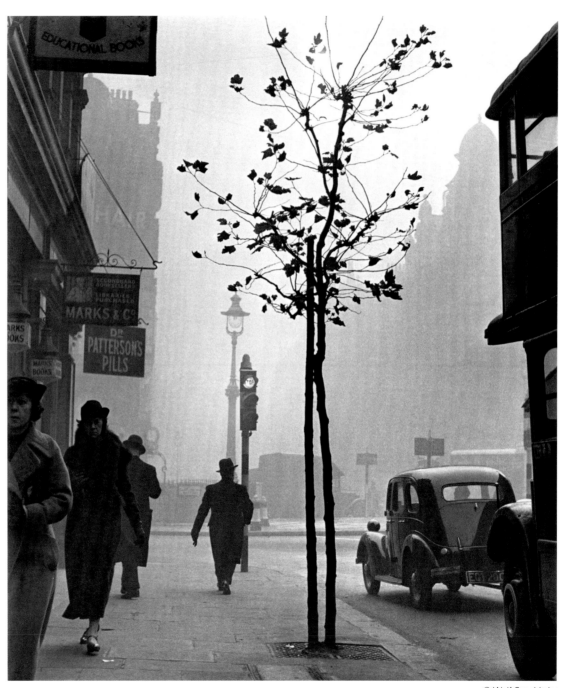

51

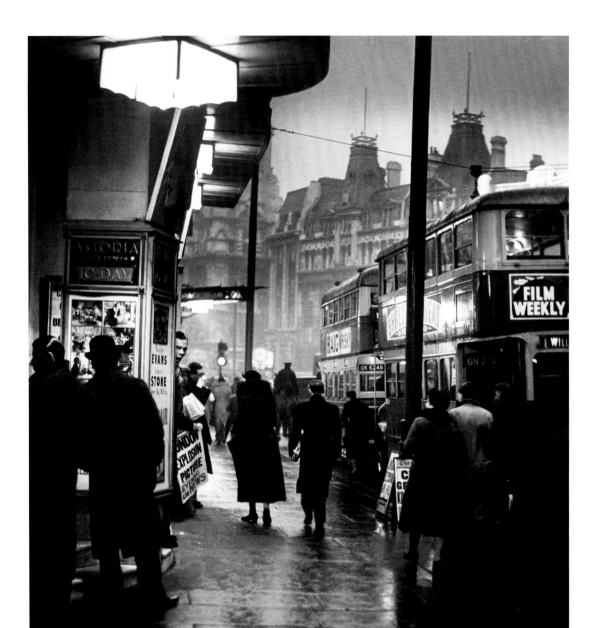

Wolf Suschitzky
St. Giles Circus,
Charing Cross Road, 1937

© Wolf Suschitzky

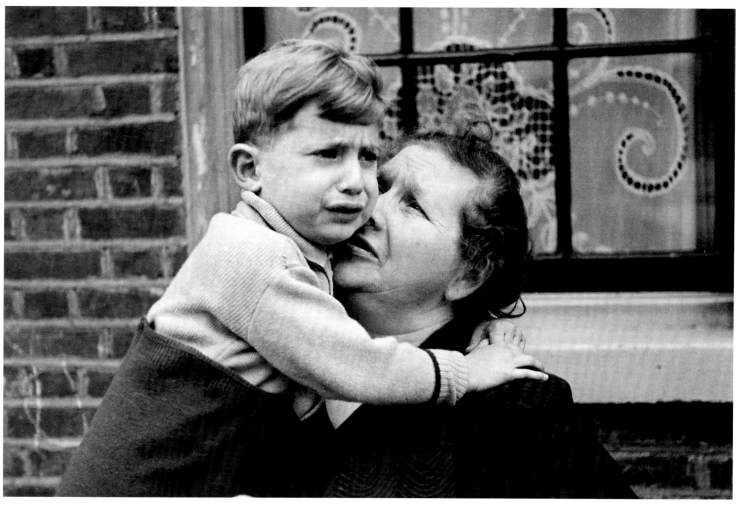

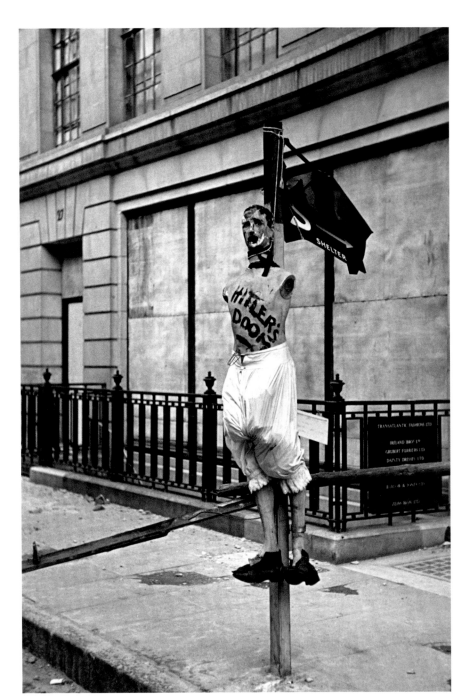

George Rodger
Hitler's Doom effigy outside
the Free French headquarters
at 4, Carlton Gardens, 1940

Bror Bernild
A street with pre-fab
houses, 1945

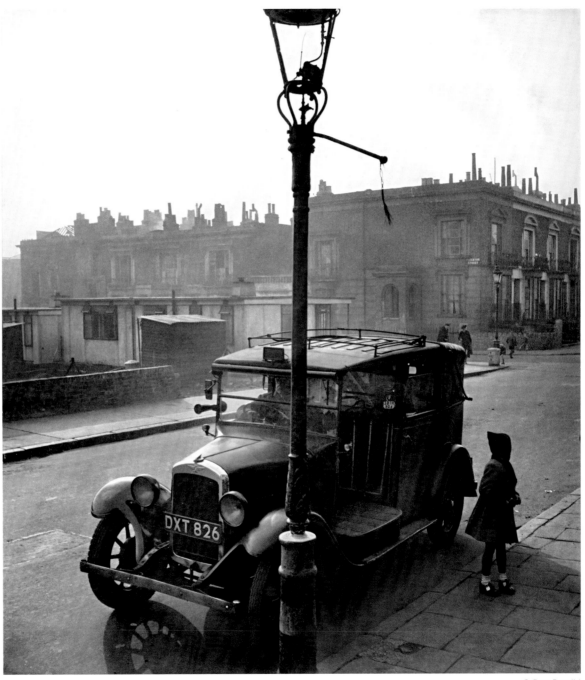

1946-1979

Nigel Henderson

Roger Mayne

Henry Grant

Bob Collins

Colin O'Brien

Corry Bevington

Anonymous

Lutz Dille

R Clark

John Drysdale

Jerome Liebling

Tony Ray-Jones

Charlie Phillips

Terry Spencer

John Benton-Harris

Sally Fear

Jim Rice

Barry Lewis

Paul Trevor

Nigel Henderson Outside a Hammersmith pub on Boat Race Day, c.1952

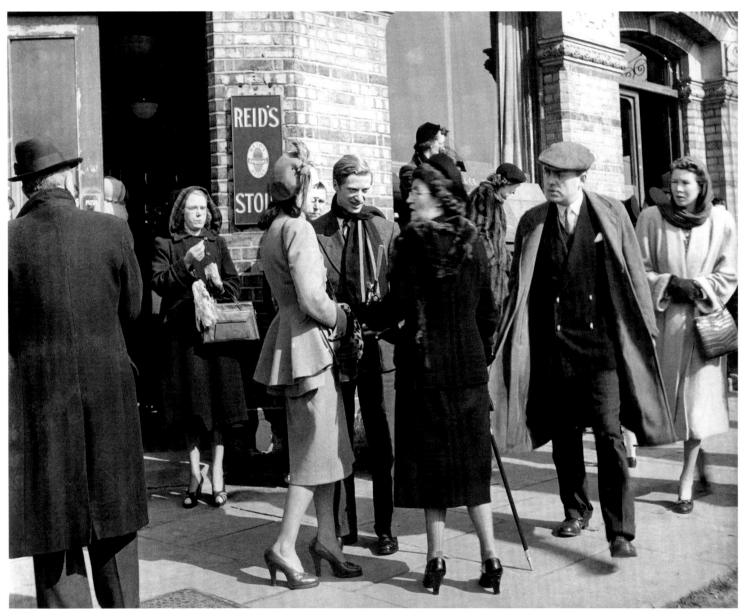

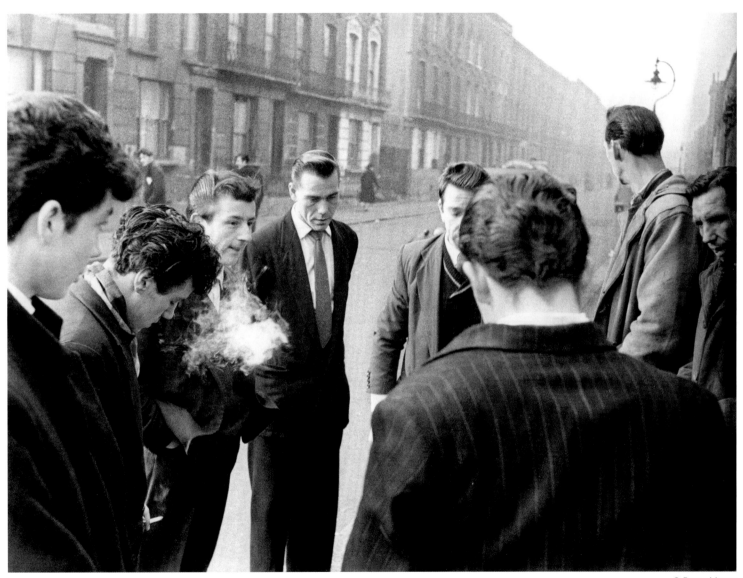

Roger Mayne Princedale Road, Notting Hill, 1957

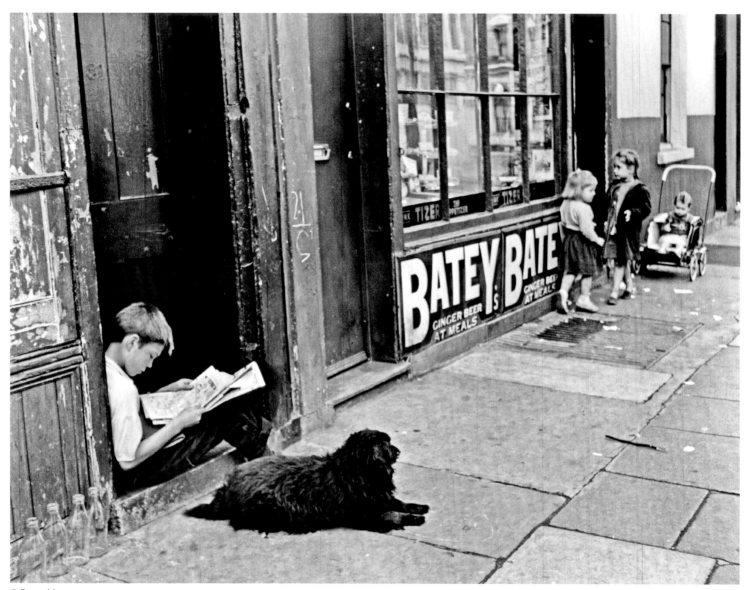

Roger Mayne
Brindley Road,
Paddington, 1959

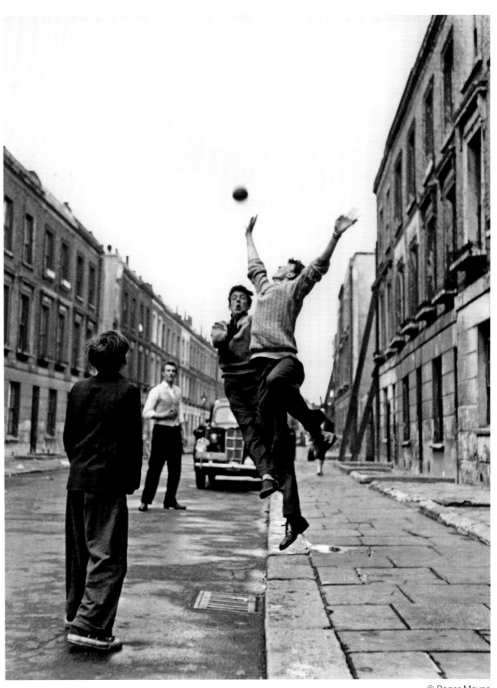

Henry Grant Petticoat Lane Market, Shoreditch, 1952

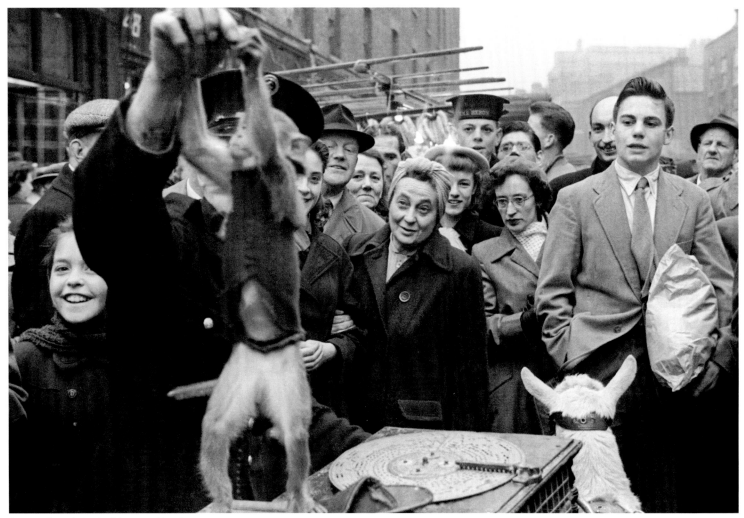

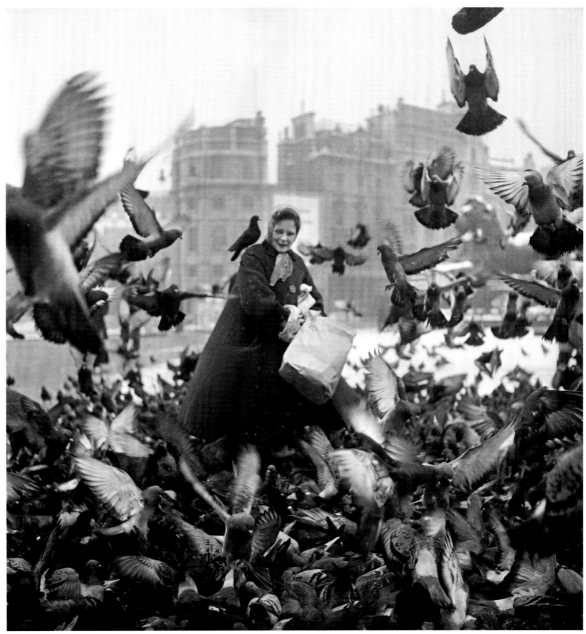

Henry Grant Oxford Street. c.1970

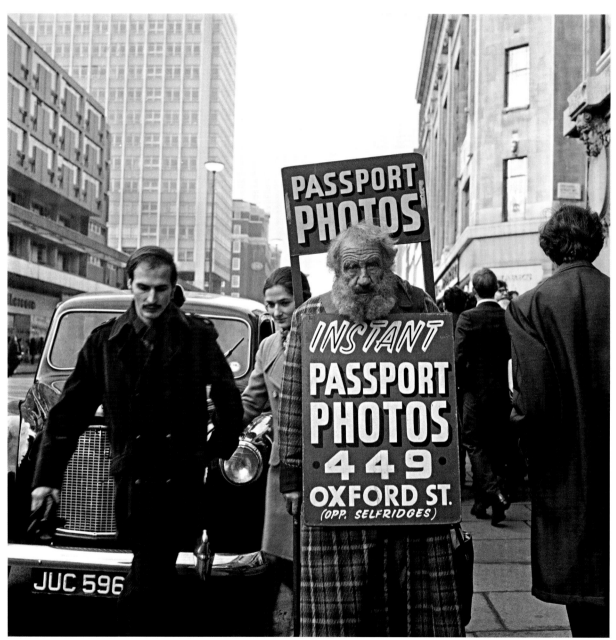

Bob Collins
Admiralty Arch on the day before Queen Elizabeth II's coronation, June 1st 1953

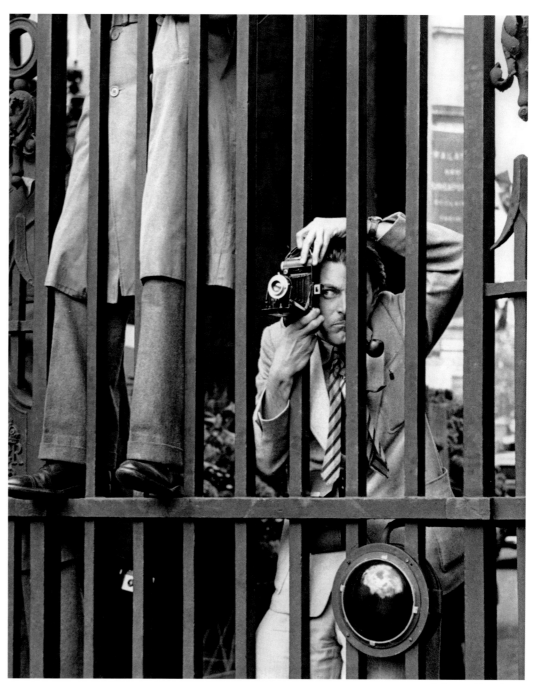

Colin O'Brien Accident at the junction of Clerkenwell Road and Farringdon Road, 1959

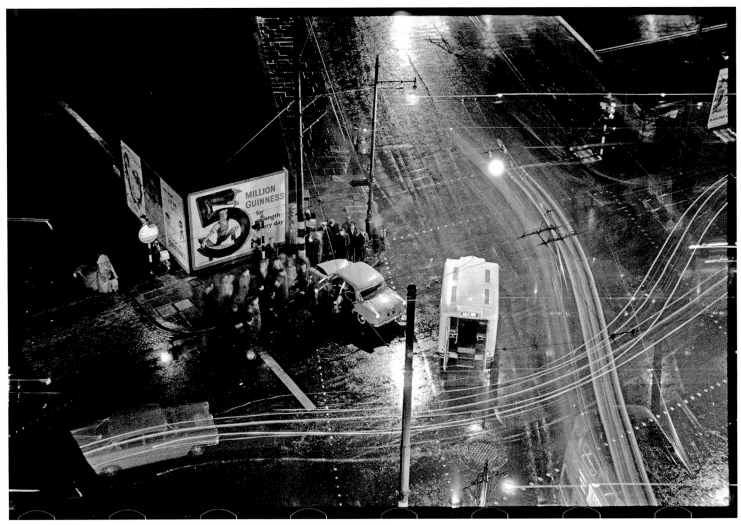

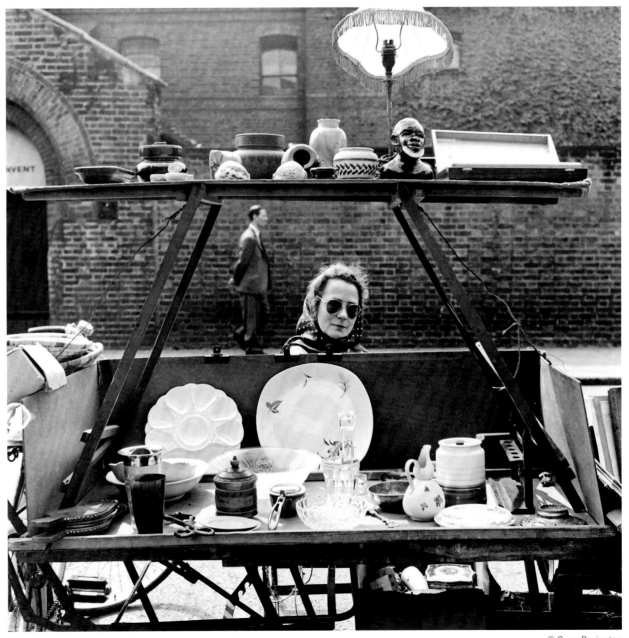

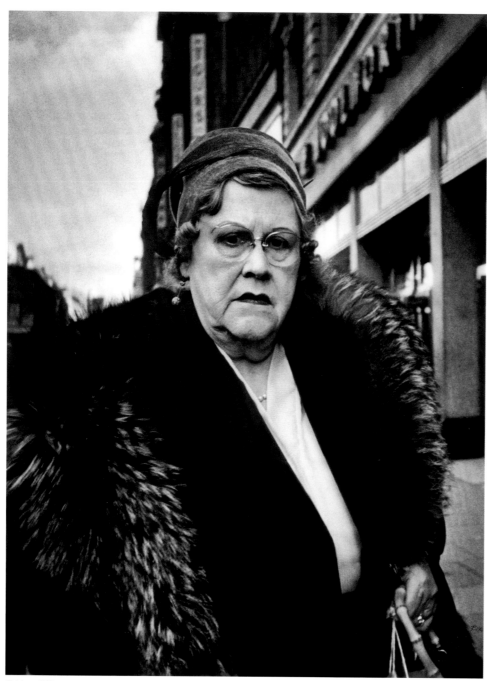

Lutz Dille
Outside a branch
of Woolworths, 1961

Lutz Dille Flower seller, 1961

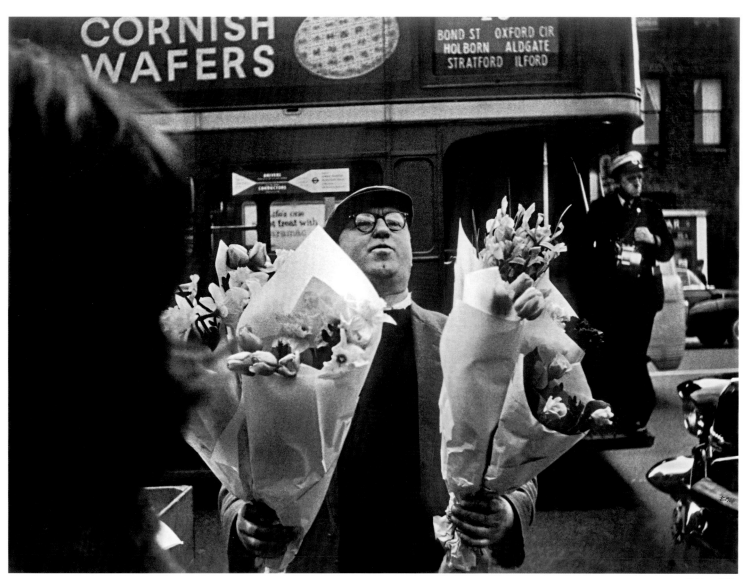

Lutz Dille Bank, 1961

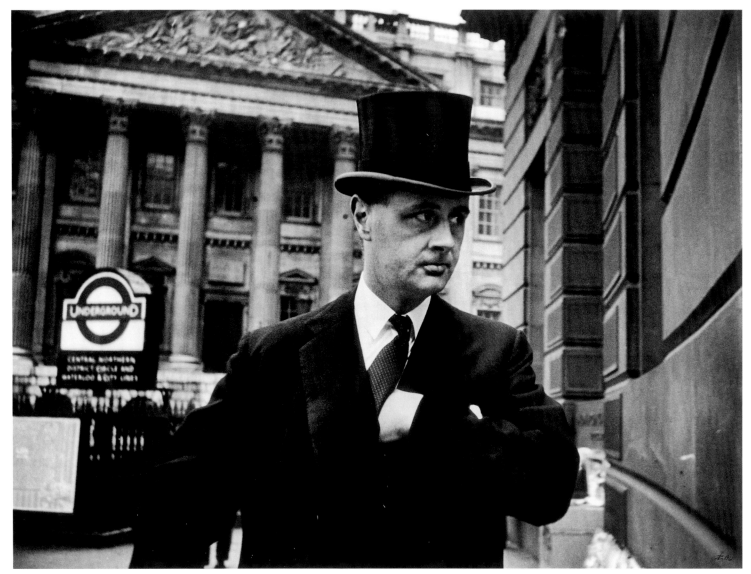

Anonymous Sunbathers by The Serpentine, Hyde Park, c.1962

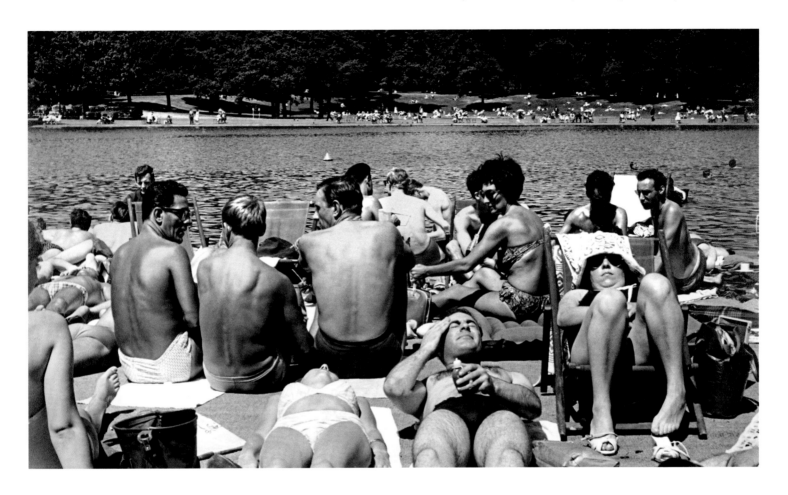

Anonymous Unidentified street scene, c.1962

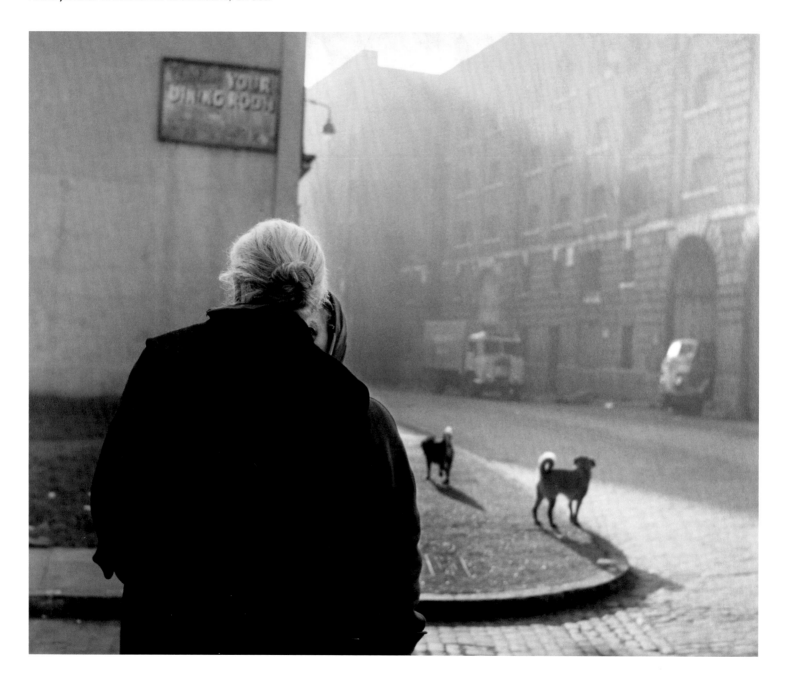

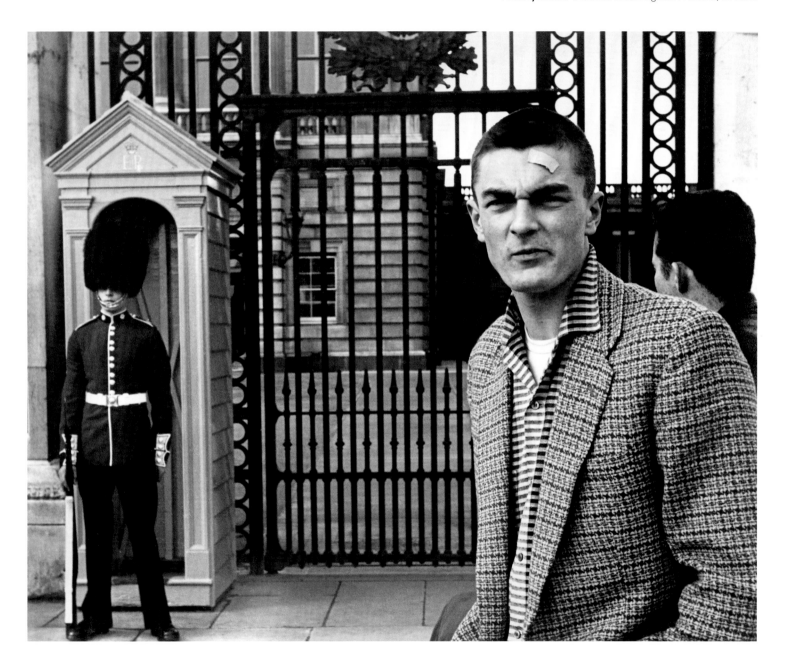

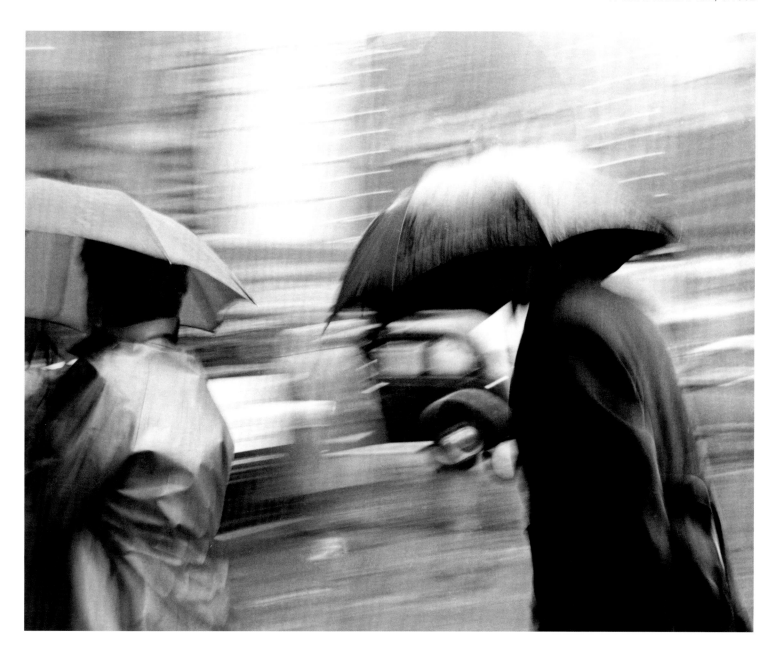

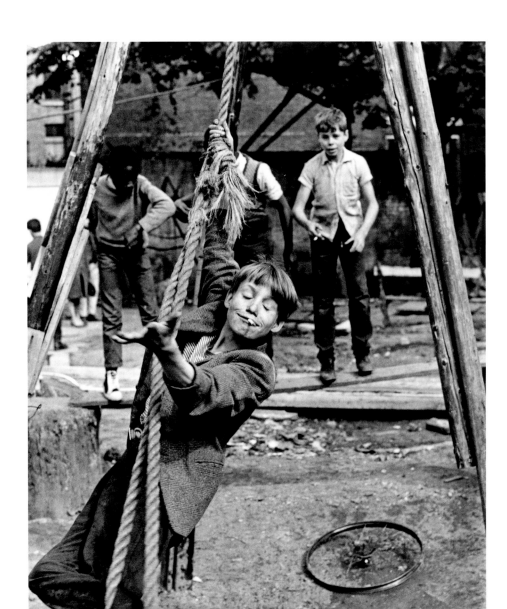

John Drysdale
Adventure playground,
September 1965

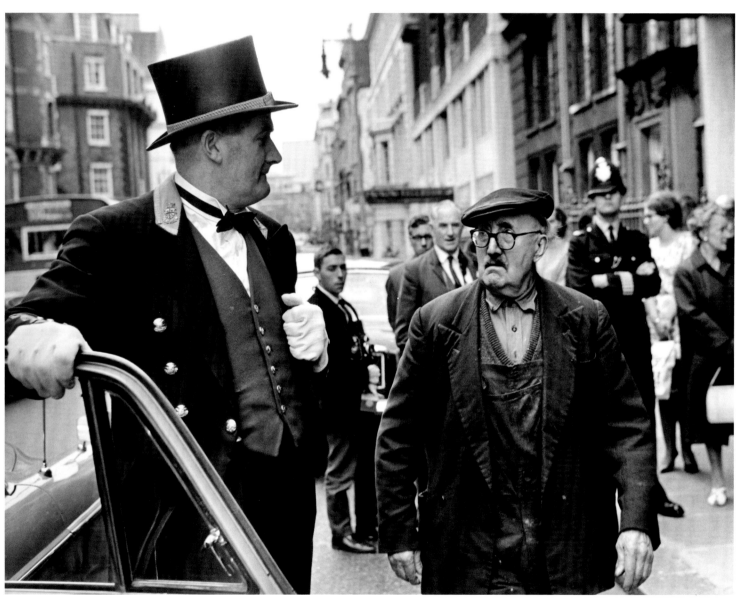

Tony Ray-Jones Notting Hill, c.1967

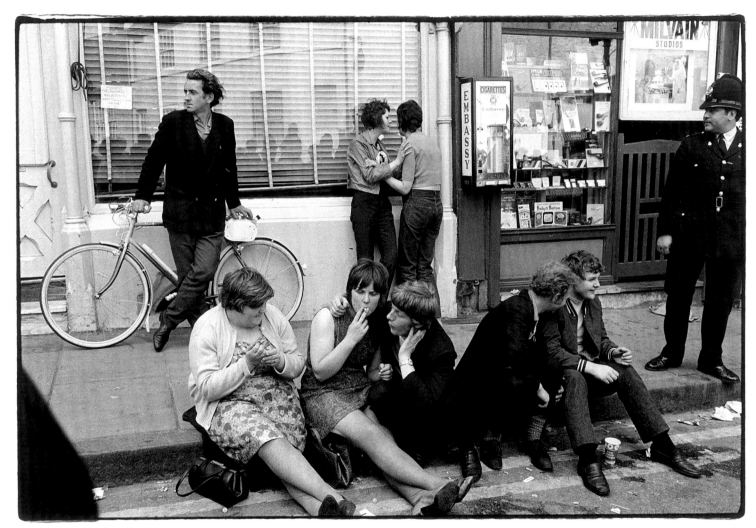

© NMeM - Tony Ray-Jones

Charlie Phillips Outside the 'Piss House' pub, Portobello Road, 1968

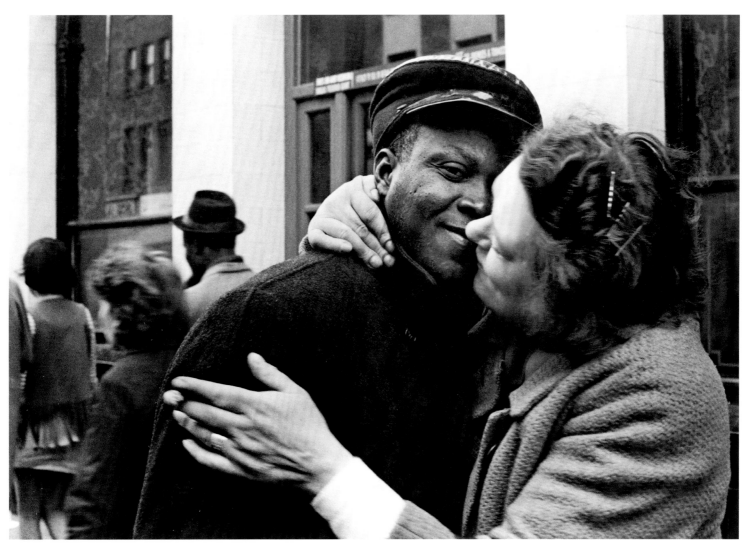

Terry Spencer On the steps of Eros, Piccadilly Circus, 1969

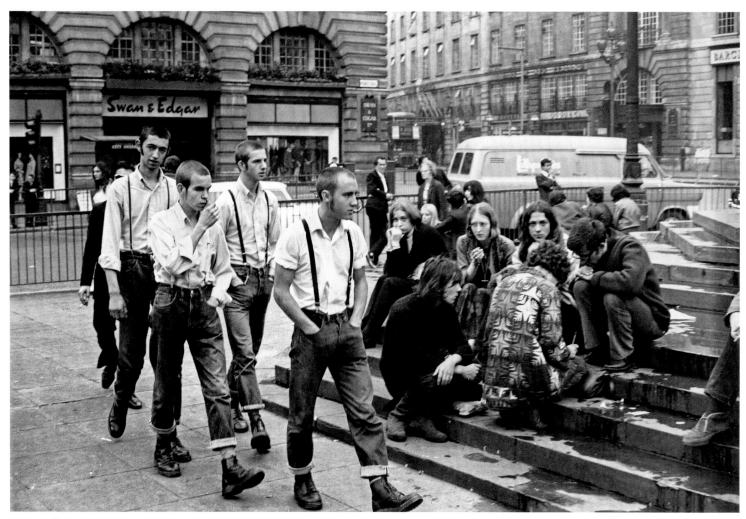

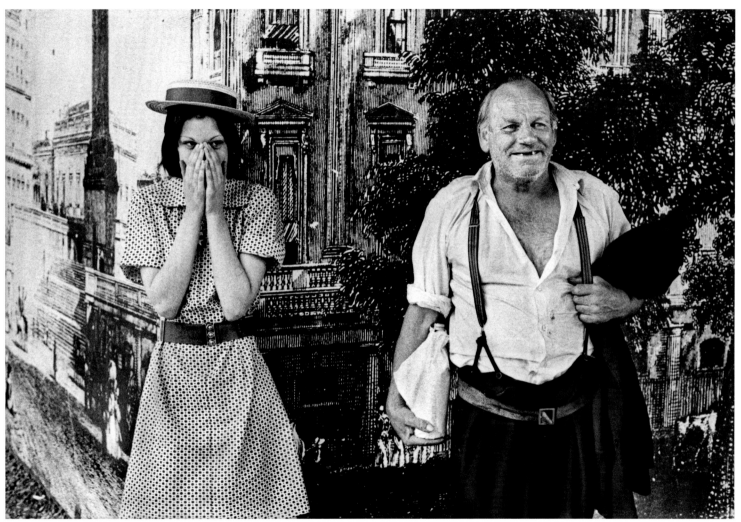

Sally Fear Chinese New Year, Gerrard Street, 1976

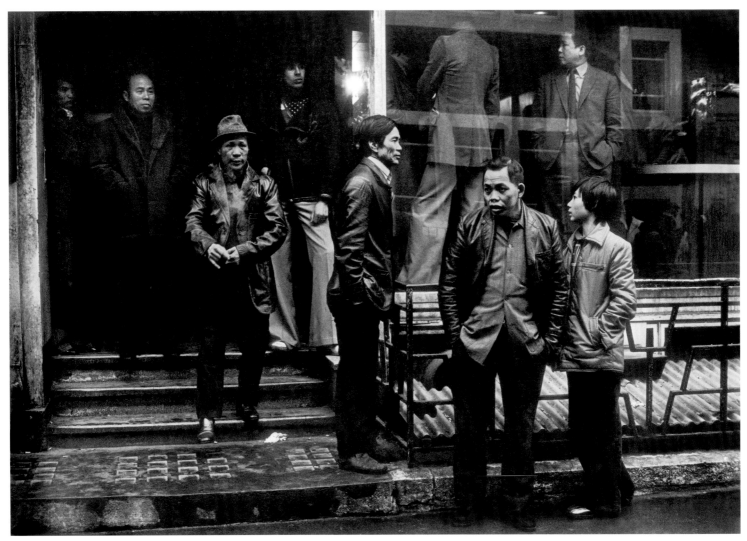

© Sally Fear

Jim Rice Lewisham, 1977

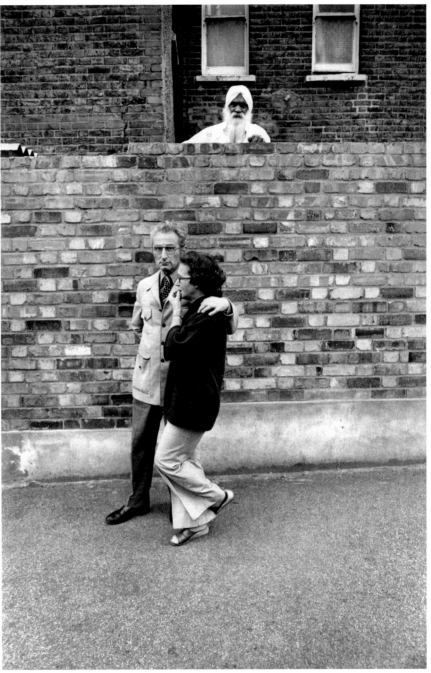

Barry Lewis A Routemaster bus on London Bridge, 1978

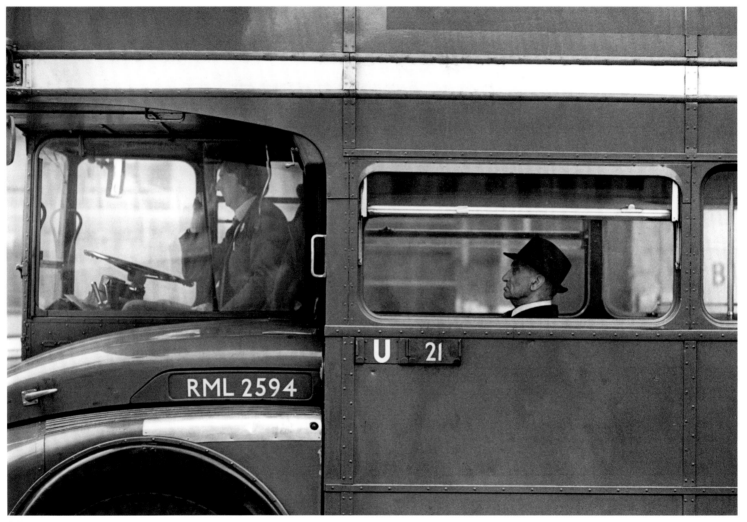

© Barry Lewis

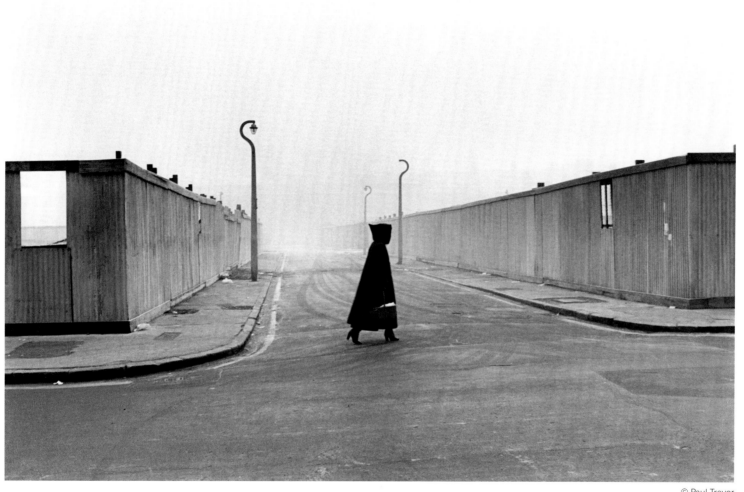

Paul Trevor Sclater Street, E1, 1987

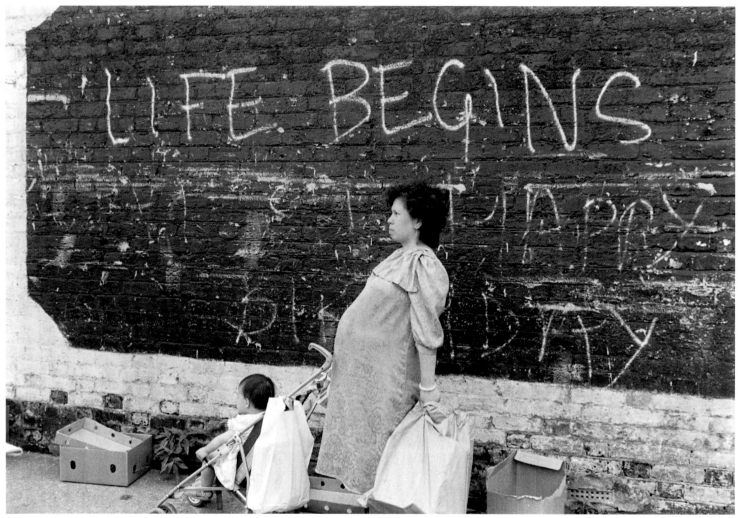

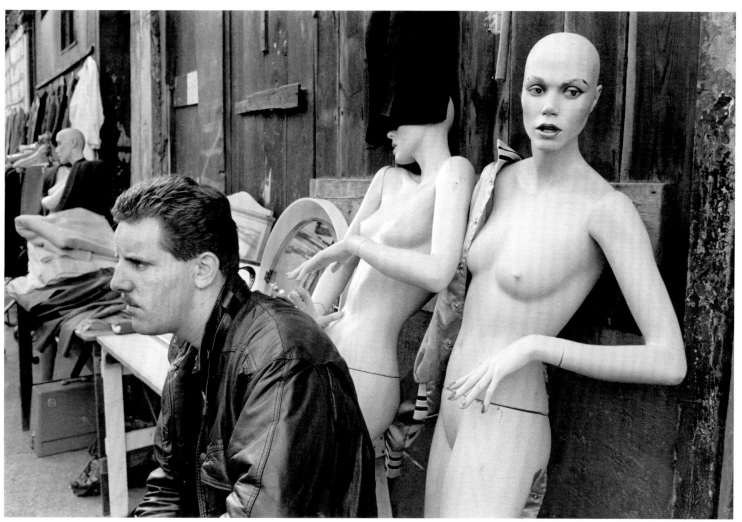

1980-2010

Bob Tapper

Lesley Howling

Peter Marshall

Sean McDonnell

Keith Cardwell

Angus Boulton

Mimi Mollica

John Chase

Richard Bram

Paul Baldesare

Polly Braden

Chris Dorley-Brown

Torla Evans

Adrian Fisk

David Gibson

Nils Jorgensen

Stephen McLaren

Paul Russell

David Solomons

Mike Seaborne

Matt Stuart

Nick Turpin

Bob Tapper Fieldgate Mansions, Whitechapel, February 1986

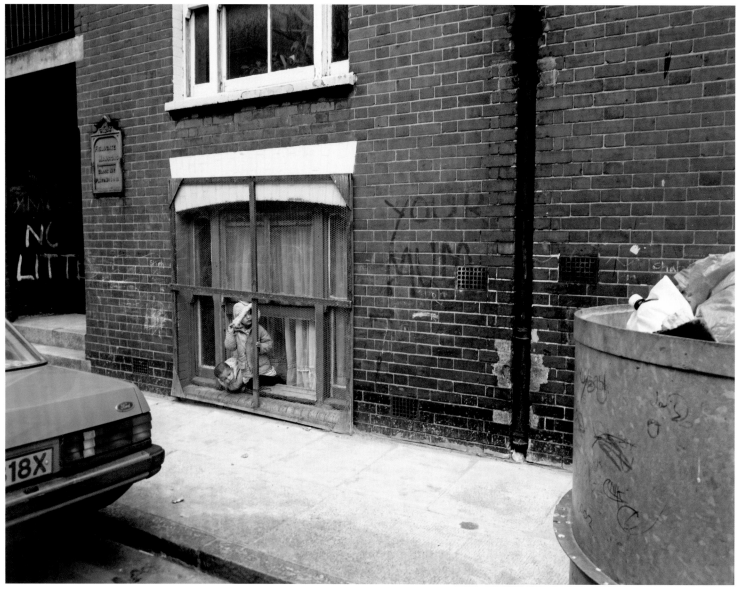

Lesley Howling Burning building, Bermondsey, 1986

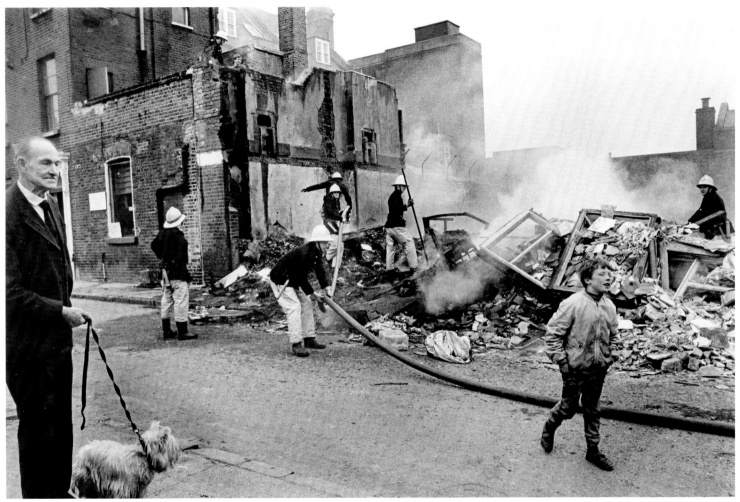

Peter Marshall Shopkeeper outside a grocery shop, Hessel Street, Whitechapel, 1991

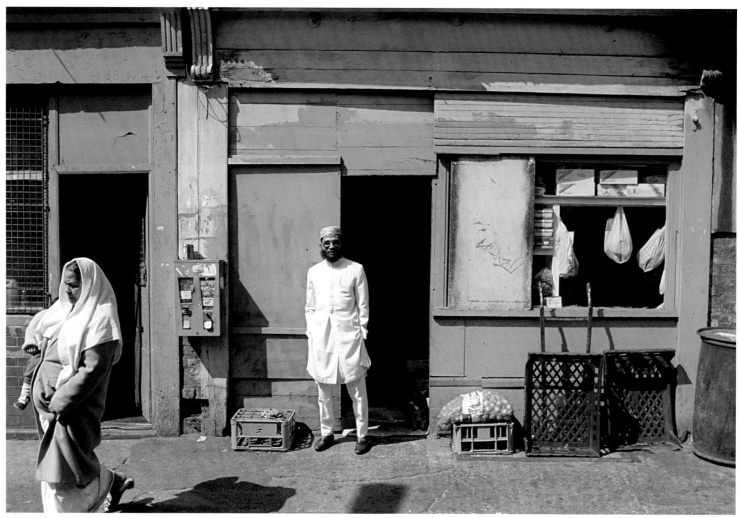

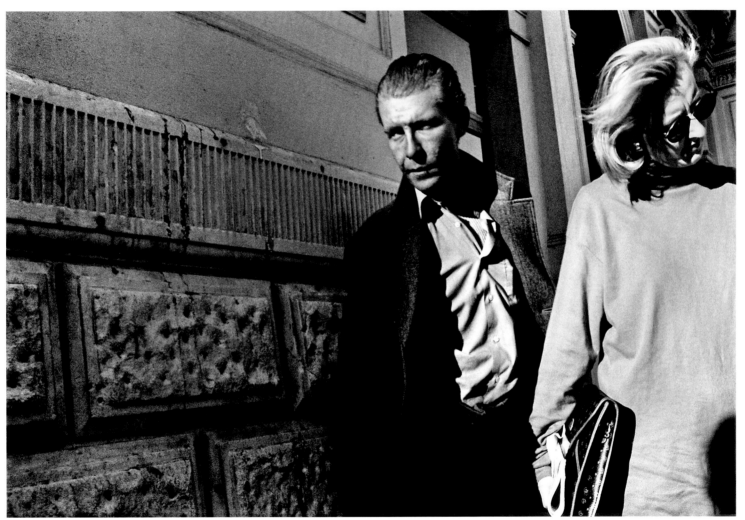

Keith Cardwell Sunday market, Cheshire Street, E2, 1991

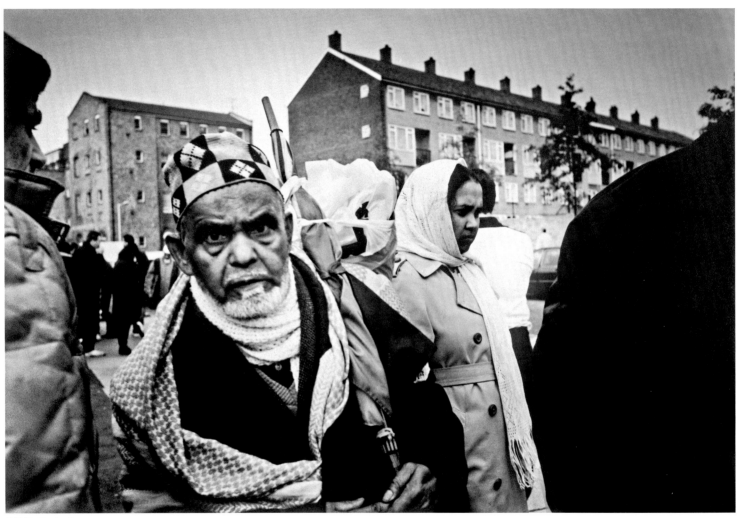

© Keith Cardwell

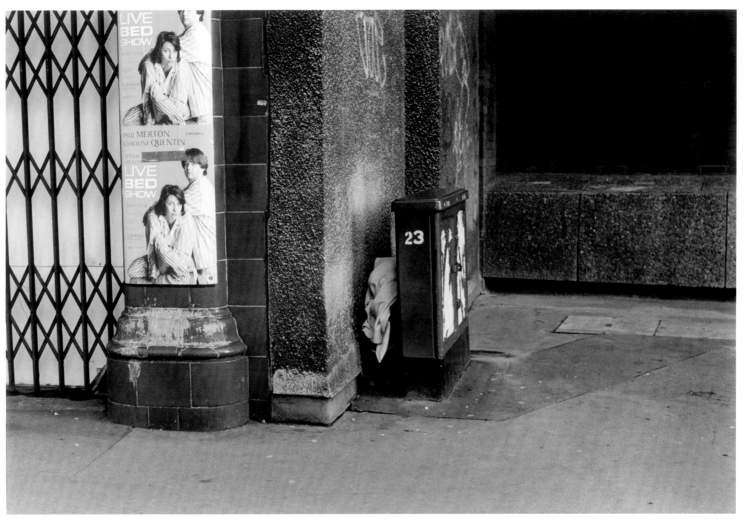

Mimi Mollica Homeless, 1997

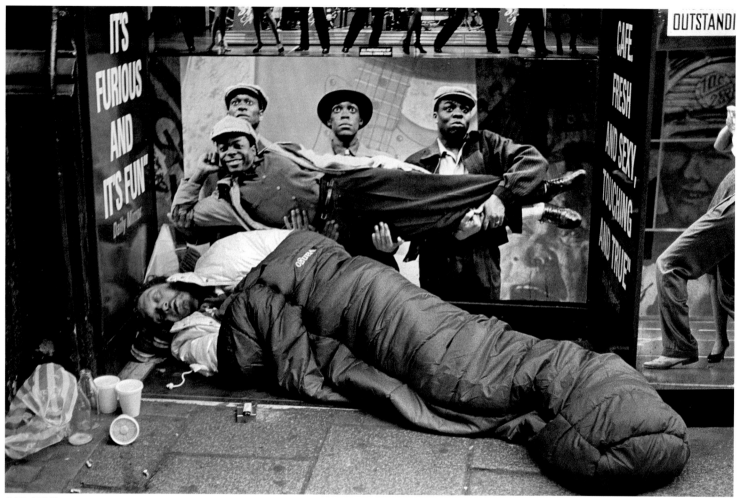

John Chase
Old Compton Street, Soho, 1999

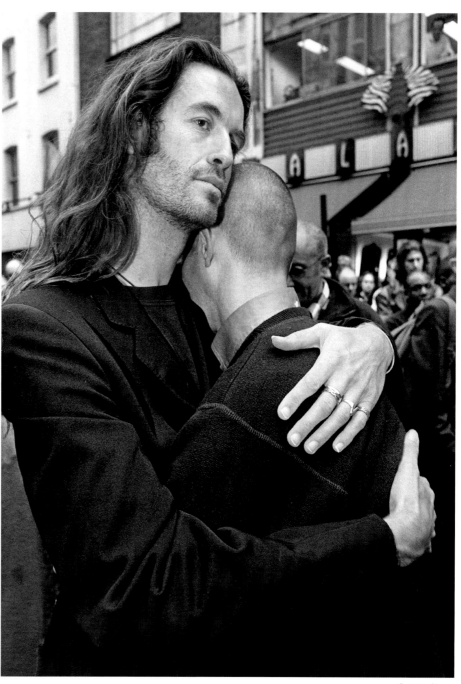

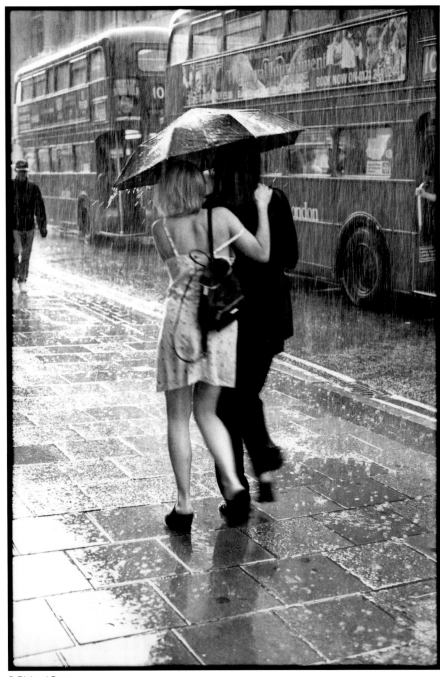

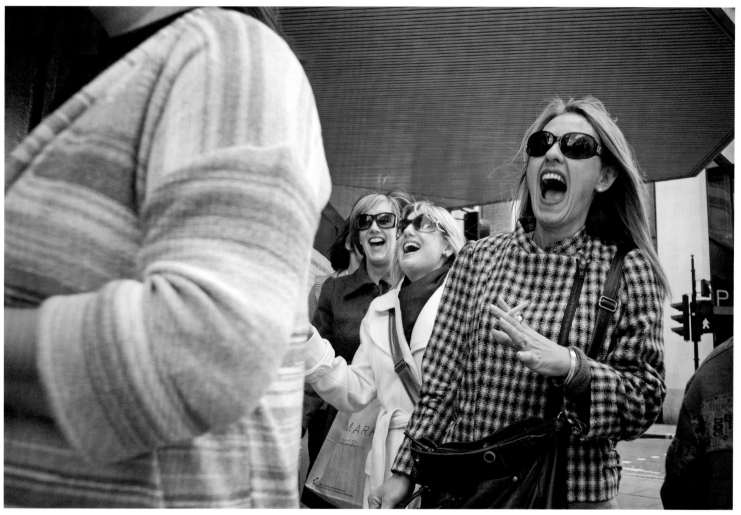

© Paul Baldesare

Polly Braden London Wall, 2009

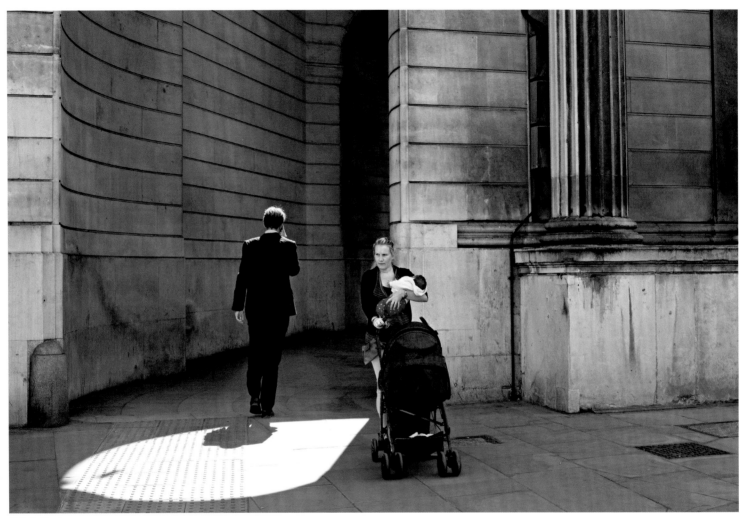

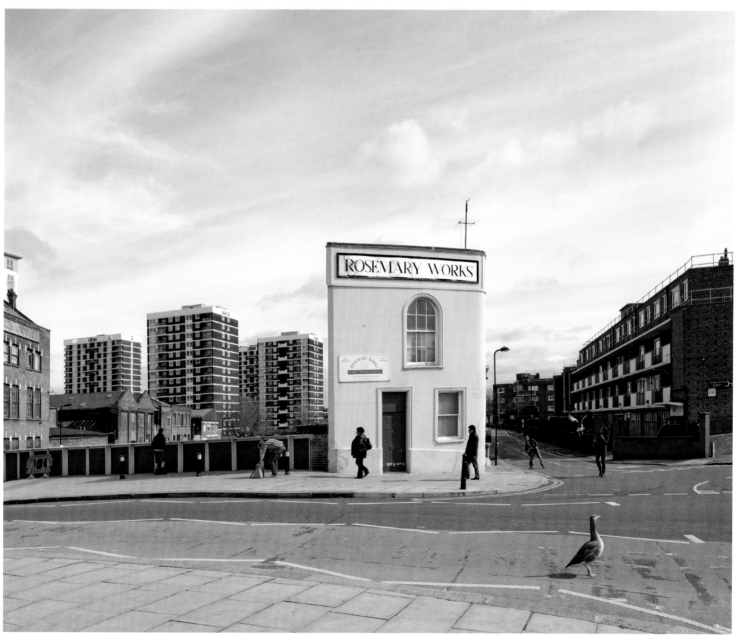

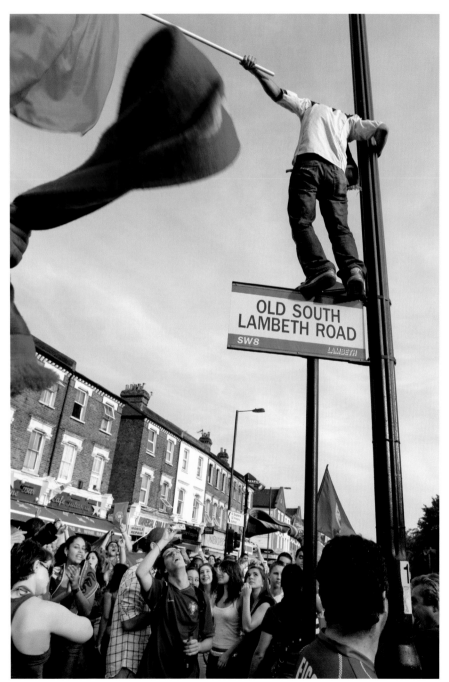

© Torla Evans

Torla Evans
The Portuguese community
celebrating victory against
England during the World Cup.
Vauxhall, 2006

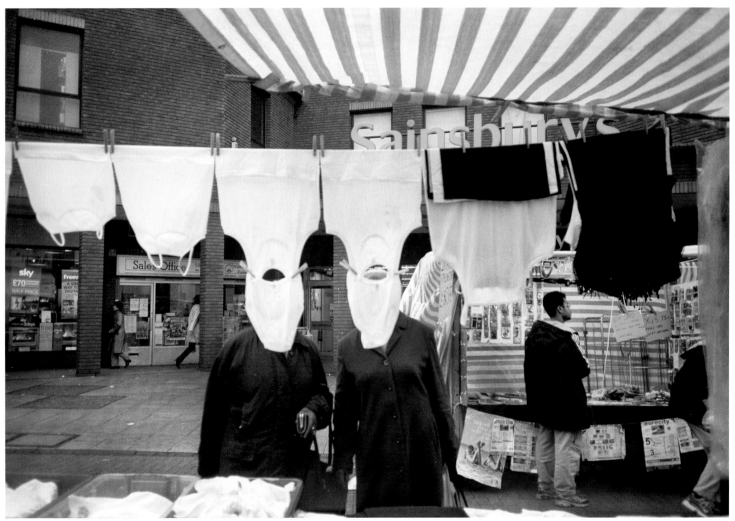

© Adrian Fisk

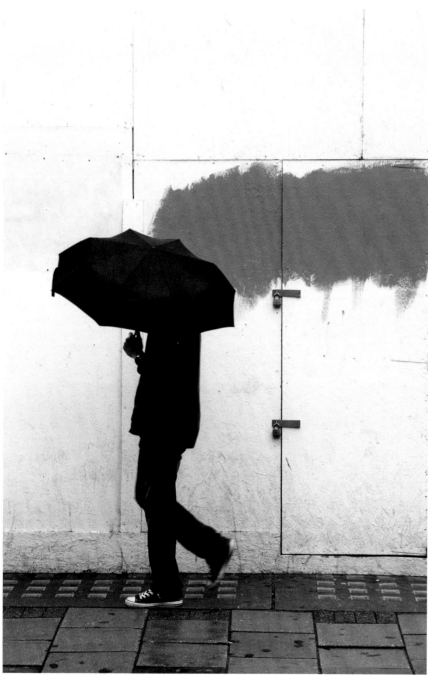

© David Gibson

Nils Jorgensen
Card Fraud, 2007

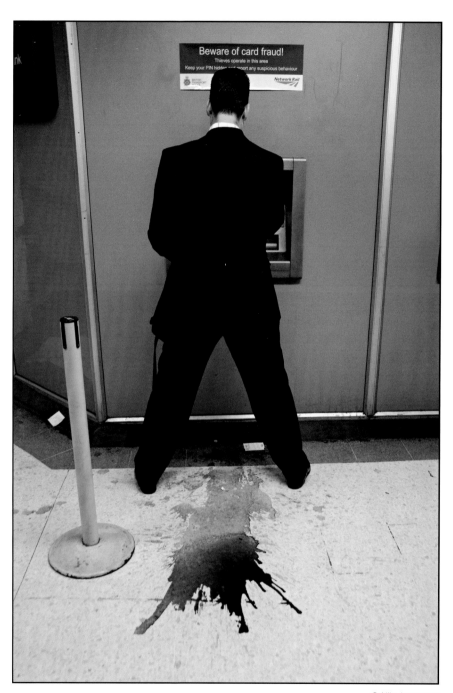

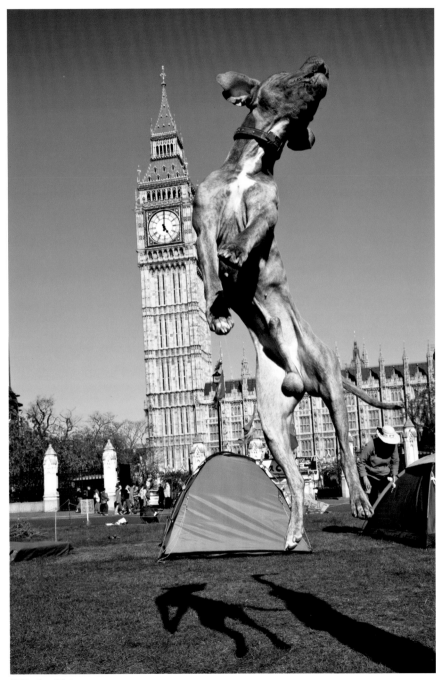

Stephen McLaren
Big Ben, April 2007

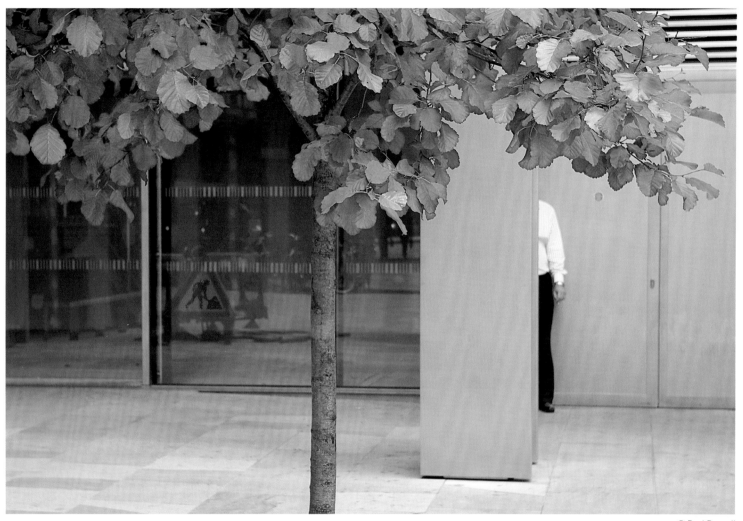

Mike Seaborne Wimbledon Bridge, June 2005

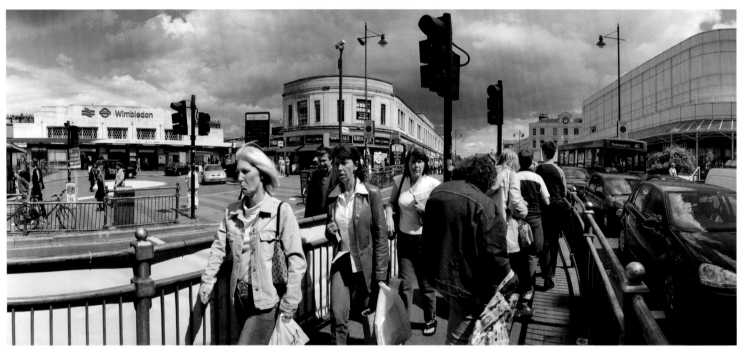

© Mike Seaborne

David Solomons England Rugby Team World Cup Victory Parade, Haymarket, London, 2003, from the series *Up West*

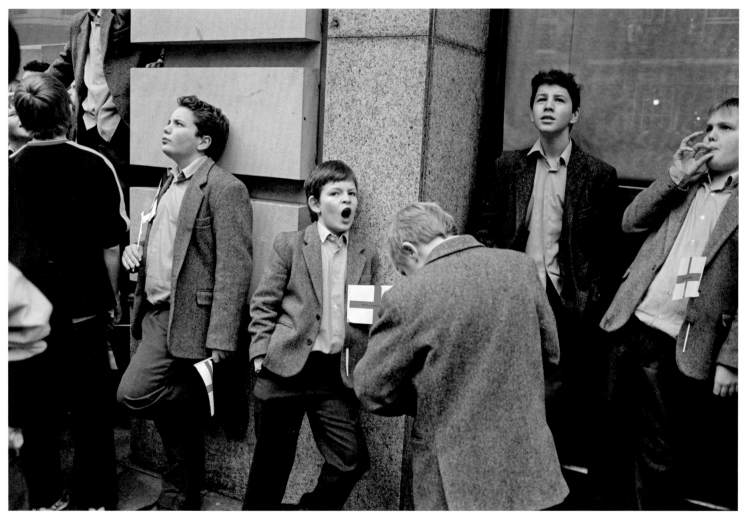

Matt Stuart Trafalgar Square, 2006

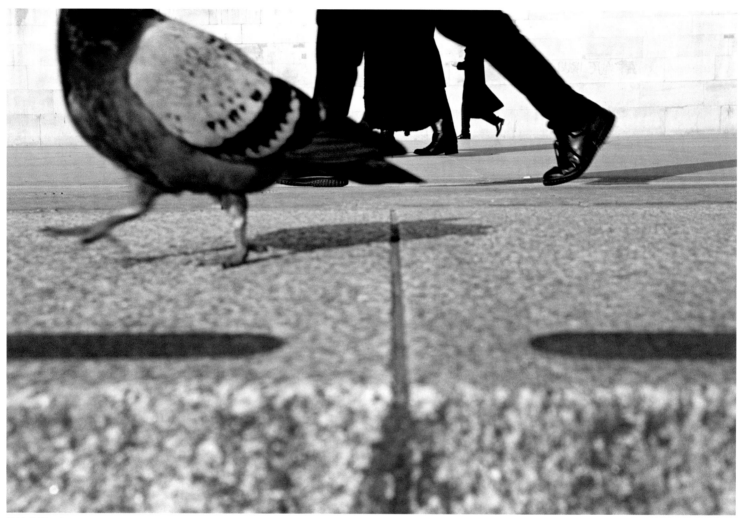

© Matt Stuart

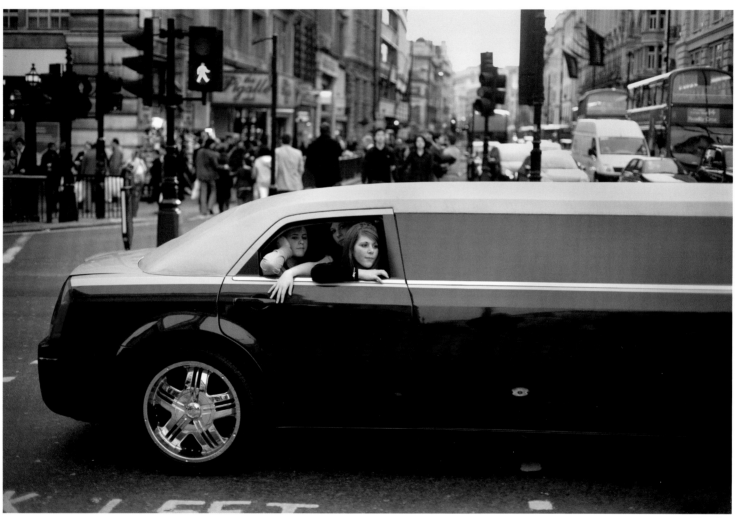

BIOGRAPHIES

in alphabetical order

Cyril Arapoff (1898 - 1976)

A Russian émigré, Arapoff's photographic eye reveals European Modernist influences. Using his German 'baby' Rolleiflex camera he opted for unusual vantage points, foreshortened perspectives and high contrasts. Having established a successful portrait studio in Oxford, he was regularly drawn to London to fulfil commissions and personal projects. Subjects included Caledonian Market, the industrial Thames and East End streets. After joining the Strand Film Company in 1941 he pursued a distinguished career in the documentary film industry.

Paul Baldesare (b.1953)

London-born Baldesare has pursued several social documentary projects in public spaces since becoming a freelance photographer in 1984. His colour work includes people on the Underground, suburban London and the idiosyncrasies of English carnivals. It is on London's busy shopping streets that Baldesare looks for remarkable gestures and expressions by individuals going about their everyday lives. He has described these locations as a kind of street theatre where ordinary people are the actors.

John Benton-Harris (b.1939)

Benton-Harris was born in New York City and attended classes during 1961-2 at the influential Design Laboratory run by Alexey Brodovitch. Following a period with the US Army in Italy, he settled in London in 1965. Benton-Harris worked as a photojournalist for *Life* magazine until it closed in 1972, after which he freelanced. He is fascinated by the English character and has been pursuing an ongoing personal project to document the English as a kind of 'visual sociology'.

Bror Bernild (b.1921)

Bernild, a leading Danish advertising and documentary photographer, ran a busy studio in Copenhagen, opened in 1942. In 1946 he published a book of his photographs called *Can we be Aware of This?* which documented aspects of life in post-war Denmark. In 1945 he visited London and made a series of photographs of the war-torn city.

Corry Bevington (b.1931)

Bevington studied photography at the Guildhall School of Arts in the early 1950s. She subsequently freelanced and was particularly interested in English canals and rural industries. She travelled to West Africa and the Yemen, photographing mud-built architecture, then spent 20 years working closely with her late husband, the graphic designer Graham Bishop. In 1981, Bevington became a founder member of the Wandsworth Photo Co-op which, in 1991, became Photofusion, based in Brixton.

Bevington, now using her married name of Bridget Bishop, is one of its directors.

Valentine Blanchard (1831 - 1901)

A prominent Victorian photographer, Blanchard was responsible for many technical innovations, including the production of instantaneous views for the stereoscope. He was not the first to do this but his photographs were extraordinary for the amount of life and action revealed in the pictures. In 1862 Blanchard issued for public sale his first series of *Instantaneous Views of London*. One reviewer marvelled that 'the cabs, omnibuses and pedestrians, in motion, some right in the foreground, (are) all perfectly defined'.

Angus Boulton (b.1964)

Despite being empty of actual people, Boulton's photographs are very clearly documentary images, which draw attention to traces of human activity and a sense of place. Boulton's award-winning project to document the plight of the homeless in London was carried out over a five year period. Boulton lives in and works from London, creating both photographs and videos.

Polly Braden (b.1974)

Braden's ongoing project, *London Square Mile*, portrays not only the expected, but also the contradictory and surprising multitude of people who walk through the City, set against the highly polished architecture. Her approach is to find a suitable location and patiently wait for the ideal subjects to pass. She says that: 'the City teems with people, but selecting just one can feel unbearably intimate'. Braden has also worked extensively in China and is widely published in leading journals and magazines.

Richard Bram (b.1952)

Bram's personal visual diary, photographing in the street almost every day, involves themes of angst, romance and humour. An American, Bram decided on a photographic career in 1984 and moved to London in 1997 where his street photography became a way of adjusting to his new home. He believes that: 'cities are stressful... yet people manage to live, love, take pleasure in life in the midst of it all, and that's what I'm trying to reflect'.

Christina Broom (1862 - 1939)

Broom was a professional photographer who made a series of London street views for sale as postcards and later photographed the activities of the suffrage movement in London. She is considered to be one of the first female press photographers. Broom's early street views are primarily topographical but a number demonstrate her desire to show un-posed life going on. This was a somewhat chancy thing to do using a large-format plate camera.

Keith Cardwell (b.1946)

In the early 1990s Cardwell photographed the streets populated by London's many different cultural communities, especially in the East End. African, Asian, Irish, Turkish and Chinese populations are all captured in these candid shots. Together with widespread publications and international lecturing, Cardwell has since become celebrated for his photography of life in Cuba, where he was also the first British photographer to be exhibited.

Hans Casparius (1900 - 1986)

German-born Casparius discovered a passion for image making at a young age, alongside a desire to act. His social circles and ambition secured him a part in a leading film, as well as the role of stills photographer. Soon he was travelling the world on photographic assignments for German and Austrian newspapers. He settled in London in 1935 opening the first studio to specialise in commercial colour photography. Post-war he focused on documentary film making.

John Chase (b. 1964)

Chase is Senior Photographer at the Museum of London. He developed his interest in photography through his involvement with the Peace Movement in the 1980s. After College he joined Lewes Museum before taking a medical photographer post at St Thomas's Hospital. Museum exhibition projects and the Historic Photographs Collection at the Museum of London have inspired Chase to look for and capture the social and historical significance within the everyday.

Bob Collins (1924 - 2002)

Collins trained and worked as a watchmaker but was interested in photography and, after writing an article which was published in *Amateur Photographer* magazine in 1952, left his job to pursue a career in photojournalism. He specialised in photographing the stars of show business, radio and television for magazines such as *Illustrated*, *Picture Post* and *Everybody's*. However, he also undertook a wide range of other more documentary-orientated work, much of which is now held by the Museum of London.

Lutz Dille (1922 - 2008)

Originally from Leipzig in Germany, Dille moved to Canada in 1951 and began a career as a photographer and documentary film-maker. In the 1960s he undertook a number of world-wide personal projects with the deceptively simple idea of photographing people 'just as they are'. During the 1960s Dille made several films featuring his photographs. One of these, made in 1961, was about London's famous Speakers' Corner and during his visit to the capital he also made a series of remarkable street photographs.

Henry Dixon (1820 - 1893)

A member of the Royal Photographic Society, Dixon specialised in architectural and construction progress photography. He also pioneered the printing of photographs using the permanent carbon process. Between 1866 and 1871 Dixon photographed the building of Holborn Viaduct for the City of London and between 1875 and 1886 undertook work for the Society for Photographing Relics of Old London, mainly photographing historic buildings that were under threat of demolition.

Chris Dorley-Brown (b.1958)

Dorley-Brown's photography is often concerned with time and space. Much of his imagery omits people, concentrating on the physical and social landscape. In 2009, however, he began a project, *The Corners*, based around Dalston in Hackney, where the inclusion of people is a central concern. Using digital composite techniques to unite multiple shots of people and locations he creates a constructed street image. Such work contributes to the ongoing debate about the 'real' within documentary and art photographic practices.

John Drysdale (b. 1929)

Drysdale studied photography at the Guildford School of Art in the early 1950s and went on to join the staff of Vogue Studios in London. He later embarked on a freelance career as a photographer and photo-journalist working all over the world. Although he has undertaken a wide range of advertising and industrial photography, Drysdale is best known for his photographs of children and animals, often done with a humorous twist.

Arthur Eason (1857 - ?)

Eason was a Hackney-based photographer with studios in Dalston Lane and Cornhill in the City of London, opened in 1875 and 1879 respectively. A recently-discovered collection of 1600 glass-plate negatives held by Hackney Museum suggests that he mainly took portraits of local people and events, including music hall artistes and the Salvation Army. Like many 19th century photographers, Eason undertook a variety of work as photography was not then divided into different areas of professional practice.

Torla Evans (b.1958)

Evans is Principal Photographer at the Museum of London. Alongside the active programme of photography undertaken for the Museum, including coverage of contemporary London life and events, she photographs in her own time in and around the city. After studying Photography at Salisbury College, Evans photographed archaeological excavations and documented villagers and Bedouin in the Middle East. She also wrote and photographed for *World* magazine.

Sally Fear (b. 1947)

In 1974, whilst working as a secretary, Fear embarked on a personal project to document Londoners at leisure on Saturdays and Sundays. Called *London at the Weekend*, the project won the first ever Nikon Award and, in 1978, was exhibited at the National Theatre. Fear went on to pursue a career as a freelance photographer and has, for a number of years, been living and photographing in the New Forest in Hampshire.

Adrian Fisk (b.1970)

After graduating in photography in the 1990s, Fisk moved to London to document youth counter-culture and to work for major advertising agencies, including Saatchi & Saatchi. Now living in India, he explores South Asian socio-political life but continues to do street photography in such contrasting locations as London. Equipped with a compact camera enabling him to react swiftly, Fisk says that: 'a prosaic walk can result in a photograph which encapsulates humour, irony and the beauty of the banal'.

John Galt (1863 - 1942)

Galt worked as a missionary in the East End of London. He took photographs to illustrate lectures he gave around the country to raise funds for the London City Mission. As a photographer, Galt's intention was to raise awareness both of the plight of London's poor and the work being done by the Mission to save their souls. Although most of his photographs were posed, he did take a number of candid street shots.

David Gibson (b.1957)

A theme running through Gibson's street photography is the incorporation of visual puns and word juxtapositions. Preferring the less-crowded street corners of London, Gibson creates graphically-styled images which convey

human stories within the everyday. He says that: 'street photography for me is an instinctive urge and after more than twenty years of wandering with my camera, it still remains about staying curious and inspired – and then looking for the luck'.

Henry Grant (1907 - 2004)

Grant opted out of his family's textile business in 1946 to take up the challenge of photographing for a living. He began by taking portraits of children but soon started to work for a Fleet Street news agency. He then embarked on a freelance career as a social documentary photographer, working with his journalist wife, Rose. Grant photographed endlessly until the early 1980s, both on assignment and for his own photo library. His extensive collection is now held by the Museum of London.

Bert Hardy (1913 - 1995)

Hardy's photographic career progressed from processing film for Fleet Street's agencies to becoming a revered figure in photojournalism. He worked for *Picture Post* from 1940 through to the magazine's closure in 1957. Self taught, Hardy covered London's war torn streets and communities. His post-war images range from documenting social conditions amongst Britain's poorest, including the Elephant and Castle, to candid street scenes. He later took his reportage style into the field of advertising.

Nigel Henderson (1917 - 1985)

Originally trained as a biologist, Henderson became an artist and was a founder member of the Independent Group, formed in 1952, which aimed to challenge prevailing modernist approaches to culture. He subsequently became closely associated with the Pop Art movement. Henderson experimented with photography and his wife, an anthropologist, introduced him to life on the working-class streets of Bethnal Green where, between 1948 and 1952, he took candid street photographs for a project run by the sociologist, J L Petersen.

Lesley Howling (1951 - 2006)

Born in Camberwell, Howling studied fine art and then travelled extensively all over the world before returning to London and embarking on a career as a freelance photographer. Her work was wide-ranging and included several record and book cover illustrations as well as portraits for magazines. In 1986, Howling undertook a personal project to document the lives of a group of travellers near her home in Bermondsey.

Nils Jorgensen (b.1958)

Jorgensen took his first photographs at the age of six in his native Denmark. Now living in London, he has honed his skills at spotting unexpected shapes, lines, juxtapositions of colour and details amidst the capital's chaotic streets to create a wonderfully witty series of images. As a professional news and celebrity photographer, Jorgensen does not specifically go hunting for street images, but with his camera always to hand, he catches sight of them in between assignments.

Barry Lewis (b.1948)

Lewis is a documentary, corporate and editorial photographer who co-founded the Network Photographers agency in 1981. In 1978 he was commissioned by the Museum of London to photograph on the theme of commuting. An exhibition of the work, called *Coming and Going*, was held at the Museum later that year. Lewis' work has been published and exhibited widely. In 1991 he won the World Press Photo Oskar Barnack Award for a photo-essay on Romania after the revolution.

Jerome Liebling (b. 1924)

Liebling is an American documentary photographer and film maker. In 1947 he joined the Photo League co-operative in New York and helped promote the status of documentary photography. The central concern of his work has always been the affirmation of the lives of 'everyday people'. In 2004, Hampshire College's media school, where he taught in the 1980s, was named the Leibling Center. In 1967, Liebling spent a year living and working in London. His photographs are a sharp observation of the social differences in British society.

Felix Man (1893 - 1985)

A German émigré, Man became one of the chief photographers with *Picture Post*, joining the staff at its foundation in 1938. As photojournalism flourished in Germany through the 1920s, Man established his reputation as a photo-reporter. Fleeing at the rise of fascism, Man came to London in 1934. Using his German-made miniature camera, the Leica, he continued his career pioneering picture stories such as *Day in the Life* and working only with available light.

Peter Marshall (b.1945)

Marshall's dedication to documenting London is evident in his blog, *My London Diary*, which has been running online since 1999. He describes it as showcasing a 'record of my day-to-day wanderings in and around London, camera in hand'. Working mostly digitally since 2002, Marshall travels all over London capturing everyday city and suburban life and the

numerous public events that intersperse it. Other aspects of his work include London's industrial heritage and the urban landscape.

Paul Martin (1864 - 1944)

Martin is a key figure in the history of street photography. He was the first photographer to roam the streets of London taking candid pictures with a disguised camera solely for the purpose of recording 'life as it is'. Martin's efforts were little regarded at the time. However, we can now appreciate both his skill as a street photographer and the insights his pictures provide of everyday life at the end of the 19th century.

Roger Mayne (b.1929)

Mayne is widely regarded as one of the 'greats' of British photography. He trained as a chemist but became a photojournalist working for magazines such as *Picture Post* and *New Left Review*. On arrival in London in 1954 he began a long-term project photographing working-class life on the streets around where he settled in North Kensington. Initially conscious of being an outsider, and somewhat intimidated by the boisterous nature of life on the streets, he gradually became a familiar and accepted figure in the area.

Stephen McLaren (b.1967)

Based in London, McLaren is a Scottish-born photographer and film cameraman. He seeks out quirky, colourful and sometimes ambiguous occurrences in his street images. His stomping grounds range from the City's financial centre in the aftermath of the credit crunch to St James's Park. Alongside his photography McLaren has led a career directing and producing for television, running hands-on street photography workshops and curating exhibitions. He is co-author, with Sophie Haworth, of the book, *Street Photography Now*, which was published in 2010.

Sean McDonnell (b.1964)

Based in London, McDonnell has practised street photography for over 20 years, working in black and white. His aim is to portray the individual within the city by creating dramatic contrast in his photographs in order to add focus to a character within the frame. McDonnell has produced two books, *Loved; Life; London*, which is a reflection on the novel, *Mrs Dalloway*, by Virginia Wolf, and *Portrait of a Street Photographer*.

László Moholy-Nagy (1895 - 1946)

The modernist Hungarian émigré Moholy-Nagy is renowned for his pioneering teachings and artistic practice with the Bauhaus movement. However, when producing a set of photographs to illustrate Mary

Benedetta's book, *Street Markets of London*, in 1936 he made traditional documentary photographs that differed greatly from his usual New Vision aesthetic. Abandoning his large-format camera, he used a fast hand-held Leica to work the streets and marketplaces.

Mimi Mollica (b.1975)

A London-based Italian reportage photographer, Mollica pursues long-term personal social documentary projects alongside his internationally published assignments. Embracing a strong sense of humanity, his work on the streets includes *London I (Exposed)*, a project which addresses Londoners' reactions to exposure in today's security conscious climate. Another project, the award-winning *Route 30, Here We Stand*, documents determined yet anxious travellers waiting to catch the Number 30 bus in the aftermath of the July 7th London bombings.

Margaret Monck (1911 - 1991)

Monck photographed for personal interest, focusing on deprived areas of inner London. She was strongly influenced by her husband, the documentary film editor John Goldman, and the photographer Edith Tudor-Hart – Wolf Suschitzky's sister. As the daughter of the Viceroy of India, Monck had a privileged background but, as an empathetic social observer, she would dress inconspicuously to document the streets of Limehouse, Shadwell, Portland Town near Camden and 'Little Italy' with her unobtrusive Leica camera.

Horace Nicholls (1867 - 1941)

Nicholls was an early independent press photographer who earned his reputation as a war correspondent in South Africa during the Boer War. Returning to England around 1900, he set up business in London selling prints to collectors, publishers and the press. Nicholls regarded himself as much an artist as a reporter and was a great self-publicist. His work in London included photographing the 'great and the good' at leisure during the London 'Season'.

Colin O'Brien (b.1940)

Born in Clerkenwell, O'Brien now lives in Hackney and mainly photographs on the streets of London's old working-class districts. He developed an early interest in photography and has been mainly employed in education rather than as a commercial photographer. Still active, O'Brien uses traditional photographic processes and continues to work in black and white. He acknowledges the nostalgic aspect of his pictures and believes that it is the commonplace which it is most important to record.

Charlie Phillips (b.1944)

Phillips was born in Jamaica and came to London in 1956. He lived and worked in Notting Hill until 1982, taking photographs of friends and neighbours for his portfolio as well as freelancing for magazines such as *Stern*, *Harper's Bazaar* and *Life*. In 1991 a selection of Phillips' personal photographs were published in the book *Notting Hill in the Sixties*, and in 2005 his work featured in the Museum of London exhibition *Roots to Reckoning*.

Tony Ray-Jones (1941 - 1972)

After studying graphics and photography in London, Ray-Jones took up a scholarship at Yale University in the USA and also attended workshops led by the influential New York art director, Alexey Brodovitch. Ray-Jones returned to England in 1965 and began a series of photographs documenting the English way of life before, as he put it, 'it became too Americanised'. A book of his photographs, *A Day Off: An English Journal*, was published posthumously in 1974 and had a major influence on a new generation of documentary photographers.

George Reid (1871 - 1933)

Reid embarked upon an ambitious project to document a pictorial walk through the cities of Westminster and London. He wanted to record the historical architecture and street views together with the activities of people and traffic. Reid photographed from an elevated viewpoint by positioning a wooden whole-plate camera on top of a portable ladder. He made over 700 photographs and wrote two manuscript books entitled *The Route Ornate*, which annotated the images with rhyme.

Jim Rice (b.1949)

Rice was born and raised in London. He grew up in Deptford and on taking up photography in the 1970s, assisted in a fashion studio before leaving to pursue a freelance career as an editorial and portrait photographer. Rice has undertaken a number of personal documentary projects, mainly in south-east London. In the early 1990s he photographed Deptford Creek during the redevelopment of Docklands and the pictures were exhibited and published by the Museum of London in 1993.

George Rodger (1908 - 1995)

As an emerging freelance photojournalist, Rodger became a war correspondent for the American *Life* magazine during the London Blitz in 1940. Rather than cover only the newsworthy events, his approach was to capture the impact of the bombing on everyday life as Londoners adjusted to the war around them. Rodger co-founded the Magnum photographic agency with Henri Cartier-Bresson and Robert Capa in 1947 and subsequently photographed across the world, specialising in Africa.

Paul Russell (b.1966)

Russell's street photography began to flourish when he embraced digital technology in 2003. Having studied animal behaviour and evolution at Nottingham University, he acknowledged that human behaviour is equally interesting and recognised that his photographic strengths lay in capturing such activity. He describes his work as 'a sort of pictorial natural history and ecology of humans'. Being based in Dorset, much of Russell's photography centres on coastal locations, but he also explores London's urban landscape.

Mike Seaborne (b.1954)

Mike is both a photographer and Senior Curator of Photographs at the Museum of London. His photography embraces both documentary and urban landscape. In the 1980s he photographed extensively in Docklands and in the 1990s did a major project on social housing. In the mid-2000s Seaborne photographed across London on the theme of The High Street. Taken with a panoramic camera, each photograph shows both sides of the street and the activities going on in between.

David Solomons (b.1965)

Solomons is a Londoner born and bred. His street photographs reflect the ever-evolving character of the city and although his work is usually project-based, he actively seeks out chance encounters and split-second reactions. His first London project, *London Underground*, was carried out whilst studying Documentary Photography at Newport College of Art and Design. This exposed him to the challenges of photographing in busy public places and the project's success led him to undertake the series, *Up West*, which explores the energy and vitality of London's bustling West End streets.

Terry Spencer (1918 - 2009)

Spencer earned the Distinguished Flying Cross as a fighter pilot during the Second World War and went on to pursue an illustrious career as a war photographer. In 1952 he began working for *Life* magazine and after photographing abroad for a number of years, returned to England to cover 1960s cults and fashions. After *Life* magazine folded in 1972 he freelanced for the *New York Times* and other US publications.

Humphrey Spender (1910 - 2005)

Spender is best known for the documentary photographs he made for the pioneering Mass Observation project in 1937. Acknowledgement of his privileged upbringing in Hampstead strongly influenced the socially concerned photographs he created for MO as an 'unobserved observer'. Spender worked as a photojournalist for the *Daily Mirror* and then joined *Picture Post* magazine in 1938. After the war he moved away from photography and pursued his interests in painting and textile design.

Matt Stuart (b.1974)

London, Stuart's birthplace, is at the core of his street photography. Working almost exclusively with a Leica film camera rather than the digital camera he uses for his commercial work, he strives to discreetly shoot pictures that capture everyday life in the Capital. These are often set within a witty context. Through anticipating moments of coincidence, observing humorous juxtapositions and by a playful use of perspective, Stuart's photographs offer an uplifting vision of the London streets he knows so well.

Wolf Suschitzky (b.1912)

Suschitzky's Charing Cross Road photographs stand amongst his most acclaimed work from the numerous personal projects he has pursued during a distinguished career. Born in Vienna, Suschitzky's socialist upbringing influenced his humanist approach to photography. Emigrating to London in about 1935 to escape the grip of Fascism, he began freelancing for magazines and working as a documentary cameraman for the Strand Film Company. His prolific cinematography included the 1971 feature film, *Get Carter*, starring Michael Caine.

Bob Tapper (b.1953)

Whilst studying for a photography degree at the Polytechnic of Central London in the 1980s, Tapper created a series of street photographs documenting a walk through the Asian communities of east London, from Whitechapel to the Isle of Dogs. Tapper went on to do postgraduate training in medical photography and imaging. He is now Head of Medical Illustration at Barts and the London NHS Trust.

John Thomson (1837 - 1921)

A Scot, Thomson learned photography in Edinburgh. Between 1862 and 1872 he travelled extensively in the Far East and then in 1873 he published *Illustrations of China and its People*. After returning to London, Thomson undertook a ground-breaking survey of London's poor called *Street Life in London*, published in 1877. This is regarded as one of the foundation stones of social documentary photography.

Paul Trevor (b.1947)

Trevor is a photographer and film maker who is widely recognised as a key figure in independent British documentary photography. He has completed a number of major projects and was a founding member, in the early 1970s, of Camerawork, an influential photographic workshop/gallery/magazine based in east London. Between 1973 and 1993 Trevor worked on an extensive personal project, called *Eastender*, which is an in-depth study of the changing community around where he was living in Brick Lane, Shoreditch.

Nick Turpin (b.1969)

Turpin has spoken of a sense of liberation when photographing on the streets compared to his commercial and editorial work. He says that: 'I am fascinated by the things that I 'choose' to photograph when I leave the house with my camera but without a 'story' or 'brief' to fulfil'. A great advocate for contemporary street photography, Turpin founded the In-Public collective in 2000 and a publishing company to promote the genre which he felt was being ignored by the mass media and commercial publishers.

Charles Wilson (1866 - ?)

Charles, son of George Washington Wilson, took over his father's photographic firm in 1888. During the 1890s he added to the firm's stock of negatives, including a series of London street views, taken using the new, faster gelatine dry plates. Wilson's method of street photography was to set up his camera and tripod inside a covered wagon, parked on the roadside and, when he judged it to be the right moment, he would whip back the cover and take a shot before anyone realised what was happening.

George Washington Wilson (1823 – 1893)

Scottish-born Wilson founded a photographic and printing company under his name in Aberdeen which, by the early 1880s, was the largest in the world. He photographed landscapes and topography extensively across the UK, including in London. Wilson conducted early experiments in 'instantaneous' outdoor photography and Valentine Blanchard credited him as a pioneer. However, his 1870s' photographs of London are primarily topographical shots made with longer exposures which prevented moving objects from being recorded.